DATE DUE

DEMCO 38-296

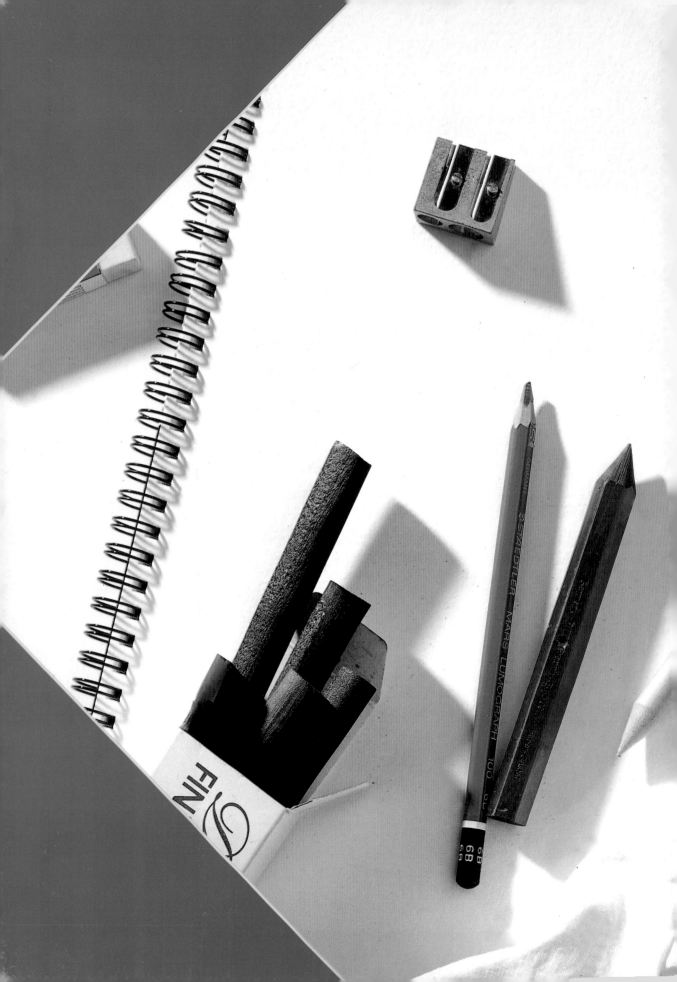

Drawing
Made Easy

David
Sanmiguel

Sterling Publishing Co., Inc.
New York

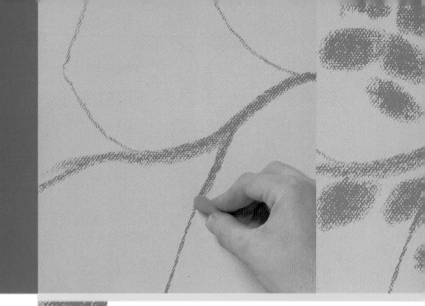

Photographs: Nos y Soto
Illustrations: Josep Torres

Translated from Spanish by John Anthony Foster
English translation edited by Isabel Stein

Library of Congress Cataloging-in-Publication Data Available

10 9 8 7 6 5 4 3 2 1

Published in 2002 by Sterling Publishing Co., Inc.
387 Park Avenue South, New York, NY 10016
Originally published in Spain under the title *El rincón del pintor: Dibujo* by Parramón Ediciones, S.A.
Gran Via de les Corts Catalanes, 322-324,
Barcelona, 08004
©2000 by Parramón Ediciones, S.A.
English translation ©2002 by Sterling Publishing
Distributed in Canada by Sterling Publishing
C/o Canadian Manda Group, One Atlantic Avenue, Suite 105
Toronto, Ontario, M6K 3E7, Canada

Contents

Introduction 7

GETTING TO KNOW YOUR MATERIALS 9
Graphite pencils and similar materials 10
Charcoal and its byproducts 11
Colored pencils 12
Drawing paper 12
Colored paper 13
Spray fixative and erasers 14

YOUR WORK SPACE 15
Work habits 16
Organizing your work space 17
Keeping work clean 18

FIRST CONTACT WITH THE MATERIALS 19
The characteristics of graphite 20
Colored pencils: a painted drawing 22
Direct mixing, optical mixing, and cross-hatching 23
A piece of charcoal 24
Blending 24
Fixing charcoal drawings 25
Sanguine in the classic style 26
The paper also counts 27
Using mixed media 28
Working with gouache 29
Some easy-to-avoid errors 30

SOME SIMPLE FORMS 31

The purity of basic forms 32

Preliminary directions 33

Questions of proportion 33

From sketch to realistic drawing 34

Other examples 36

Practicing and drawing 37

The art of simplicity 38

A LITTLE PERSPECTIVE 39

The horizon line 40

The vanishing point 41

One or two vanishing points 42

The unseen vanishing point 43

When art and perspective went hand in hand 44

TO DRAW IS TO COMPOSE 45

Measurements and proportions 46

The viewing frame 47

Transferring measurements to paper 47

The image on the paper 48

The frame and composition 49

Interpretation 50

Layout and composition of a seascape 52

LIGHT AND SHADOW 53

Shading: values 54

Values with shading or line 55

Shading and values with charcoal 56

Blending: hands or a blending stump? 57

Values and shading with chalk 58

Chalk, sanguine, and pastel: from values alone to color 59

Modeling the figure 60

Light and shadows on the figure 61

Masters of colored drawing 62

PERSPECTIVE AND SHADING IN LANDSCAPES 63

A landscape with colored pencils 64

Representing light 66

LAYING OUT AND SHAPING THE FIGURE 71

A pencil sketch of a figure 72

A face in profile 74

A sketch with sanguine and toned chalk 77

LINES AND SPOTS: DRAWING ANIMALS 81

Correcting mistakes 82

LANDSCAPE DRAWINGS WITH DIRECT COLOR 87

Autumn leaves 88

A landscape under a blue sky 90

Index 96

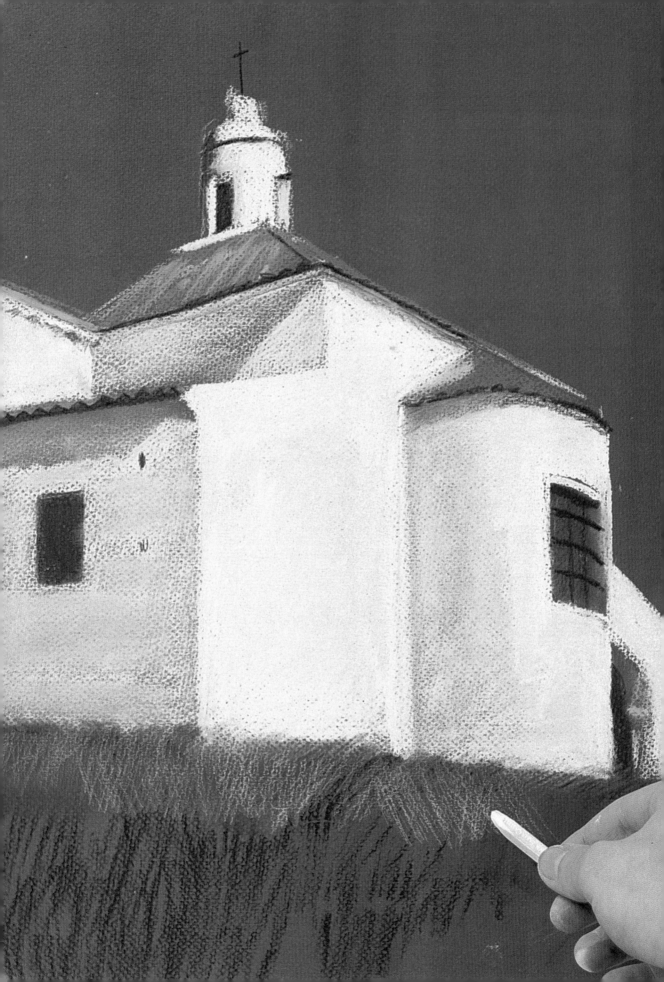

Introduction

As everyone knows, drawing is the foundation of every type of artistic work. But, above all else, it is an enormously gratifying activity that does not require a lot of equipment, space, or money. The only thing that is necessary is a little bit of time and dedication to start you on your path to interesting results. This book will show you the path in a quick, pleasant, and direct way.

In the first section of this book, you will find a complete introduction to the materials necessary for drawing, along with explanations of how to use pencils, charcoal, chalks, pastels, drawing paper, erasers, and other helpful things. There are also suggestions on how to organize your work space as well as some helpful hints and art secrets that will help you avoid unnecessary problems.

The middle section of the book deals with key drawing issues, such as representing light and darkness, light against shadow, perspective, and other techniques that comprise the essence of this art form. It is important to note that you do not need any prior experience or knowledge of these techniques. The book contains simple, organized instructions and detailed illustrations so that you will not have any difficulty learning and mastering drawing.

Gradually, almost without your realizing it, you will begin to discover the techniques and resources that every artist uses. When you reach the end of the book, you will be able to draw the final drawing without any trouble. The illustrations are photographed sequentially to show the distinct aspects of each stage of the work. The step-by-step photos, with the accompanying explanations and suggestions, are the best instructions a book can offer. Drawing is the first step towards painting, but, most importantly, drawing is an end in itself, an activity that allows us to appreciate the charm, harmony, and beauty of real forms, and a rare opportunity to be creative in a world that becomes more and more conventional each day.

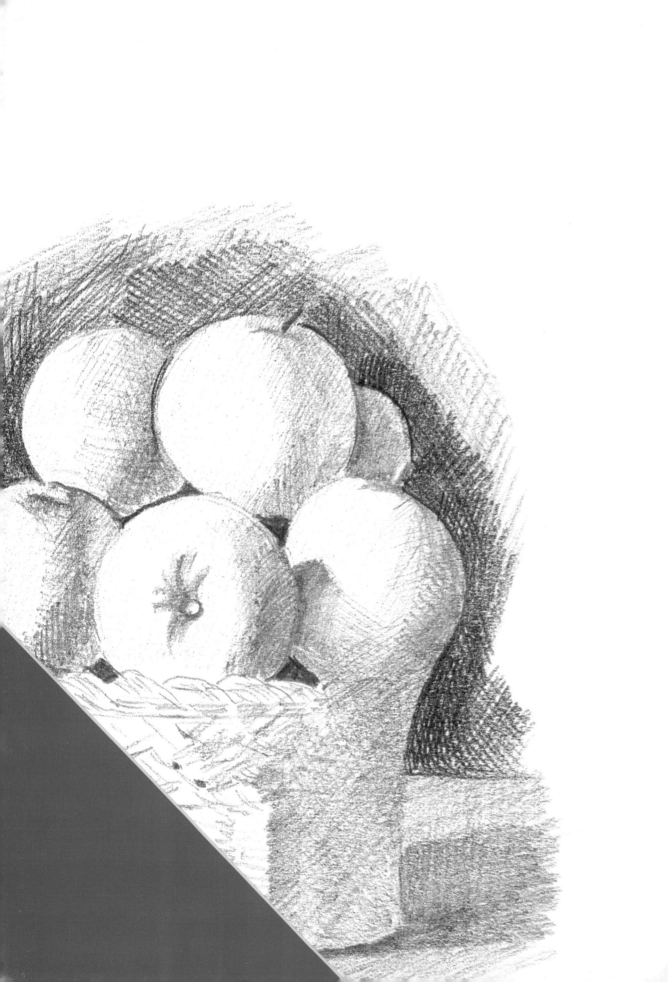

Getting to know your materials

Materials for drawing are commonplace. Some popular items, such as pencils, are available in many varieties. We suggest that you use quality materials from the beginning in order to learn the skills needed to get the most out of your artistic activities, however much or little time you have to spend on them.

You only need three things in order to draw: a pencil, paper, and the desire. Surely you have the desire to draw, and you probably have a pencil and a sheet of paper; but your pencil and paper may not be the right kind. For example, your pencil may be too hard, which may not give your pencil stokes their optimal effect; or your paper may be too thin, which may cause it to rip when you erase. There is a widespread opinion that beginners should start out using lesser quality materials; this is wrong. Beginners, more than anyone else, should start with high-quality materials. There are new techniques to learn — you shouldn't also have the bother of working with inadequate drawing materials, which makes learning to draw seem much harder than it really is.

◆

There are many new techniques to learn—don't add the problem of working with inadequate drawing materials

◆

The list of drawing materials that follows is not exhaustive — it has only the basics: graphite pencils, colored drawing pencils, charcoal sticks, charcoal pencils, and drawing paper. Other drawing materials are introduced and explained later in the book. How to organize your work space also is explained, along with some good work habits for keeping it organized. It always seems that we have little time to draw, so it is good to take full advantage of the time and not waste it in searching for misplaced materials. It is very important to have a special space for drawing, no matter how small it may be, for your materials, portfolios, drawings, and clippings (images, photographs, illustrations, etc. to serve as inspiration or as models). Dedicate the space to drawing.

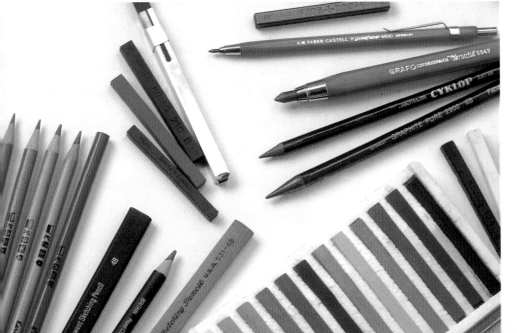

Knowing the characteristics of your materials is fundamental before starting. Each tool gives specific and unique results that no other medium can duplicate.

Graphite Pencils and Similar Materials

Obviously you know what a pencil is and that it draws a dark gray line. What you may not be aware of is that the darkness of the line varies according to the hardness of the lead, which is made from a mineral called graphite. This variation in hardness allows us to use light and dark lines to get dark or light shading. A number and a letter, engraved onto the pencil's side, indicate its hardness. Pencils with the letter H have hard leads and make thin, light lines while those with the letter B have soft leads and make strong, dark lines. The number that accompanies the letter indicates pencil's hardness or softness; the higher the number, the harder or softer the lead is. The picture at the left shows pencil lines of the most frequently used drawing pencils — soft and medium-hard. A good selection to begin with is: 5B, 3B, B, and HB. In the photo below we show some basic materials for pencil drawing.

Soft pencils are recommended for drawing. Their lines are intense, which makes shading much easier. A good selection of pencils should include at least 3 soft pencils and one medium-hard pencil such as HB.

Materials for drawing with graphite: Pencils, pure graphite sticks, graphite leads for lead holders, and a sandpaper block for sharpening.

TOOLS FOR GRAPHITE PENCIL DRAWING

1. A woodless graphite pencil that may be sharpened like a regular pencil.

2. High-quality pencils that are perfect for all kinds of drawing.

3. This pencil sharpener accepts two widths of pencil.

4 and 5. Lead holder that accepts leads of different widths. The leads are sold separately.

6. Thick lead for the lead holder.

7 to 10. Professional-quality pencils.

11. Graphite stick for large drawings.

12. A sandpaper block for sharpening.

13. Standard-quality eraser. It unfortunately makes a lot of eraser dust.

14. Holder for square chalks or pastels.

15. Special rubber eraser for graphite.

16. Flat graphite stick for wide shading.

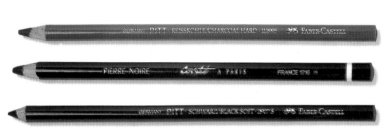

On the left are charcoal sticks of different widths. Medium-sized sticks are the best to begin with. Below, three charcoal pencils: softer pencils are the most commonly used, because they make dark lines.

Charcoal and Its Byproducts

Charcoal is the oldest and simplest means of drawing. As you can see in the photo at left, charcoal sticks are irregular and of different widths. This is because they are of plant origin, carbonized willow branches. It is good to begin with medium-sized sticks, since the narrow ones tend to break easily. In addition to the basic willow charcoal sticks, there are also pencils of charcoal mixed with clay; these are stronger, more stable, and create darker lines than stick charcoal. You can apply charcoal directly to the paper. Charcoal frequently is used to do preliminary sketches for paintings.

Colored Pencils

These pencils are made of pigments held together with clay and wax. There are many varieties, and each brand has different assortments of colors, which can include a range of 150 tones. The reason for this variety is that it is difficult to mix the colors, so it's always better to apply the color unmixed. Nevertheless, a selection of 20 or 25 colors is enough for most drawings. An assortment can be bought as a set, or colors can be bought individually.

GRAPHITE AND CHARCOAL

The basic difference between graphite and charcoal is that charcoal is dry and graphite is oily. Because charcoal is dry, it does not stick to paper very well. However, charcoal spreads easily on paper and makes it possible to create all kinds of tonal areas.

Set of high-quality colored pencils, one of the most extensive arrays of colored pencils on the market. Having many colors helps you avoid having to mix them, which isn't too easy to do with colored pencils.

HARD AND SOFT COLORED PENCILS

Colored pencils also come in hard and soft varieties. In general, the soft colored pencils are better, because they have more pigment and can make thicker lines. Hard colored pencils usually are of student quality. Their color is not as intense, and the hardness of the lead leaves furrows in the paper. These furrows become visible when you paint over them, which can ruin the final effect of a drawing.

Drawing Paper

The final appearance of a drawing depends a lot on the paper you use. A good paper always allows your pencil drawing to have optimal effect, gives texture to your shading, and assures its permanence. Paper for pencil drawing should be smooth-grained so that the shading remains dense and thick. Paper for charcoal drawing, on the other hand, should have a medium grade so that the charcoal dust can adhere to the ridges. The photos on this page show which types of paper you should use for each technique. The paper should be thick; paper that is too thin cannot withstand erasing and also wrinkles and rips too easily. Popular manufacturers sell drawing paper in drawing pads, as well as loose sheets. Big manufacturers stamp their trademark in each sheet with a watermark (it is called this because they stamp the sheets while they are still wet) that is visible against the light.

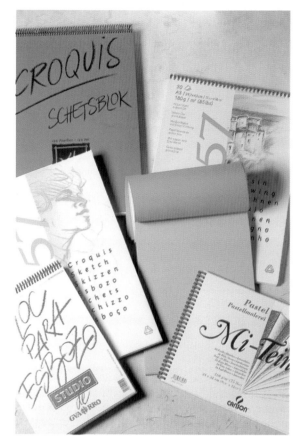

Drawing pads allow you to keep your work together in good condition. Also, the rigid back of the pad acts as a support when you do not have a table. The paper should not be smaller than 12 inches (30 cm) on its longest side.

This is the texture of Basik. It is heavy, resistant, and has a good surface for all drawing styles. This kind of paper may be used for all types of drawing techniques.

Canson sketch paper is good for sketching and notes. The grain is too fine to use for more elaborate work, and it is not good for charcoal drawing.

This is the texture of the Canson paper Mi-Teintes. It is good for charcoal and pastel drawing. It has many uses and comes in a wide range of colors, including cream, ochre, and gray papers, which create the typical tonality for charcoal drawing.

This is the texture of an Ingres type of charcoal paper. This is the most common type of paper for charcoal drawings. Although it is has a rather fine texture, if gives excellent results for sketches and more elaborate drawings.

Watermarks of two high-quality papers. They represent a guarantee from the manufacturer of the paper's quality.

A small drawing pad, which can fit in your jacket pocket, should always accompany you in the country or the city. A pad and a pencil or small sanguine artists' chalk are all that you need to sketch.

Colored Paper

Sometimes the bright whiteness of the paper is too cold and aseptic for the artist, especially when the pencil lines are dark black. This effect can be avoided by using colored paper. A huge variety of colored papers, from cream to dark blue, is available in most art supply stores. It is common to use light-colored papers, such as clear ochre, pale sienna, green-grays, green-blues and cream, for most techniques. Besides smoothing out the contrasts, colored paper allows you to use white chalk to create hightlights and lights. The choice of color depends on the theme of the drawing: for figure drawing, it is best to use warm colors; grays and greens are better for landscapes.

INEXPENSIVE PAPER FOR SKETCHING AND PRACTICE

Good-quality drawing paper is expensive. To experiment with different effects, sketch, or try out new techniques, it is less expensive to use lesser quality paper. It gives good enough results for our experiments. Fortunately, there are many choices available. One is package-wrapping paper (also called kraft paper). It comes in very wide rolls, which allow you to draw huge pictures, using almost any technique. It usually is brown, but it also may be found in blue, green, and red.

To the left are swatches of Canson Mi-Teintes papers. It is best to choose the lighter colors when drawing with traditional techniques.

A roll of kraft paper is very economical and lasts a long time. You can cut different-sized pieces to do quick studies, sketch, or try out new techniques before beginning your actual drawing.

Spray Fixative and Erasers

One of the biggest problems of drawings is their preservation: colors will fade when exposed to the sun, charcoal will wear off, paper will deteriorate in time as well, etc. Don't worry! Every problem can be avoided by taking some precautions, such as spraying a fixative onto the finished drawing, keeping the drawings in a portfolio if they are not framed, and keeping them away from direct light and humidity. Keep the paper vertical and spray on the fixative about 12 inches (30 cm) away from it. Only spray on light coats, let them dry, and then spray again until the pencil, charcoal, chalk, etc. does not smudge when you touch it. Learn which eraser to use for each medium. Graphite pencil marks erase with a rubber eraser, but to erase charcoal marks you will need a kneaded rubber eraser, which is softer and more absorbent. You can also use a clean cotton rag to erase charcoal.

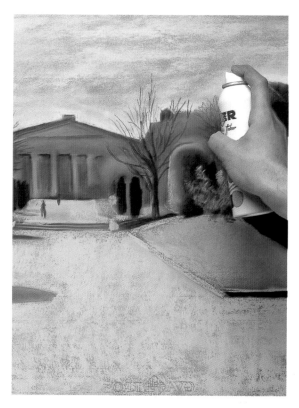

Hold the drawing vertically with the fixative about 12 inches (30 cm) from it. Spray light coats, let dry, and reapply.

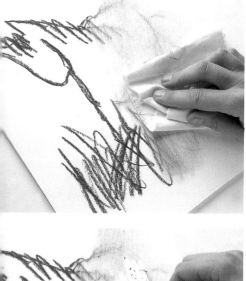

Before erasing a big section, use a clean cotton rag to get rid of most of the charcoal dust.

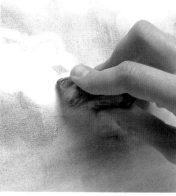

Kneaded rubber not only is an eraser, but can also create open areas in the charcoal marks that let the paper show through.

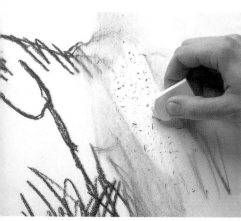

After you have wiped the area with the rag, use a white rubber eraser (the kind used to erase graphite pencil) to eliminate the remaining charcoal marks.

Kneaded rubber erasers can be molded like clay. They absorb the charcoal marks and can be used over and over.

Your work space

You can turn any corner of your home into a little drawing area. Your studio needs only a little space, furniture, and light. Natural lighting is the best, but artificial lighting is also acceptable as long as it is bright enough and does not tire your eyes.

Even if you live in a small apartment, there is always a space that can be turned into a drawing or painting studio, a place that can be dedicated exclusively to these activities. A big space is not necessary: a medium-sized table next to a window is enough; with a little organization, such a space can hold all your art materials.

Studios soon end up full of all kinds of things, not only portfolios and drawing materials, but also many items that you only used a couple of times. For this reason, order is important. However disorganized a studio may look, you know where to find things, but it is a very good idea to develop the habit of organizing your space after each work session or at the end of each day.

The best kind of artificial lighting comes from halogen lamps, but they are on the expensive side, delicate, and use a lot of energy. Fluorescent lights, which can be attached to the ceiling or the walls, are the most practical and economical lighting. They give off a generally good light, last a long time, and use little energy; however, their light has a green undertone which, although not very noticeable, can sometimes affect colors. By combining different colors of fluorescents or by mixing conventional light bulbs and fluorescents, you can obtain lighting that is the most similar to natural light.

All of these suggestions are for the ideal work space, but basically, what is important is that you have sufficient lighting to see what you are drawing.

It helps if your studio furniture has wheels; you can move it when you are not working, in order to save space.

◆

No matter where you live, you can find a space that be turned into a drawing and painting studio

◆

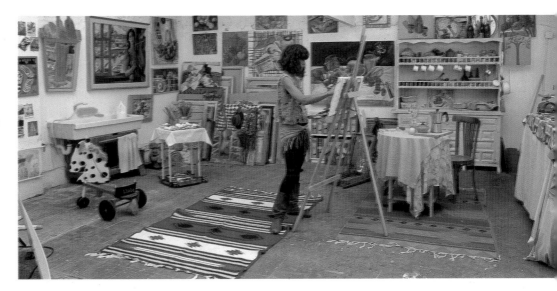

An artist's work space expresses his or her personality, interests, and artistic style. Lighting, space, and furniture are important considerations.

You can draw while you are seated. Attach the paper to a drawing board and hold it at an angle. The best way to work, however, is standing up, with the drawing board on top of an easel.

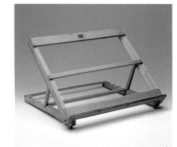

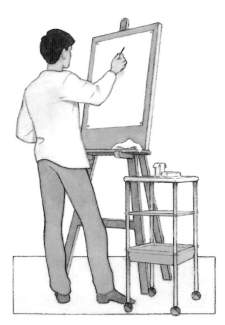

Work Habits

A drawing stand is shown in the above photo. It is very comfortable to draw on while you are seated, because it holds the paper at a good angle.

To take full advantage of your work space and equipment, you must know what the basic necessities are for anyone who wants to draw. You can draw at a conventional table while you are seated. The paper should be fastened to the drawing board, which should be facing you and angled in an almost vertical position. Rest the drawing board against the table, or use a drawing stand like the one in the above photo. An easel gives you more freedom to move — because you are more agile when you are standing. Whichever setup you decide upon, make sure that you have enough room to step back now and then and view your work from a distance.

OTHER MATERIALS
In addition to pencils, charcoal, paper, and other drawing materials, always have scissors, a craft knife, and a ruler handy. Since it is sometimes more economical to buy paper in rolls or in big sheets, you will need to be able to cut them to the desired size. It is a good idea to have a metal ruler and a T-square (in order to get right angles) as well as a rubber or plastic cutting mat to place under your work so that you do not cut your work table's top.

These tools are indispensable for cutting paper. The cutting mat helps you to avoid cutting your work table.

Organizing Your Work Space

A space in one of your rooms can be converted into a drawing studio. Dedicate this space, no matter how small it may be, solely to drawing. In it place your work table, preferably near a window to receive natural light. An adjustable tabletop, like the kind drawing tables have, is ideal (it can be angled, raised, and lowered), but you can place a drawing board against the edge of the table, or use a little work stand instead. A small chest of drawers can help you to store and organize your drawing materials. Papers, used as well as new, should always be stored in portfolios and folders, because they tend to get ruined fairly easily otherwise. Due to their small sizes, drawing tools can become lost and misplaced often; it is important to keep them together in a metal or wooden box that is big enough to hold charcoals, pencils, cutters, erasers, pens, conté crayons, chalks, and other tools.

Portfolios are essential for storing your drawings as well as your unused paper. After buying your paper, immediately place it in a folder of suitable size.

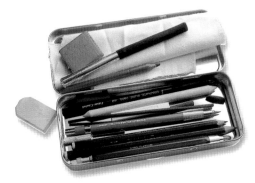

Above is a typical metal box for storing drawing tools, which otherwise may be easily lost or misplaced since they are so small.

Your work space should be near natural light, which is less tiring to your eyes, but artificial lighting is also acceptable. A table with an adjustable top makes drawing even more comfortable.

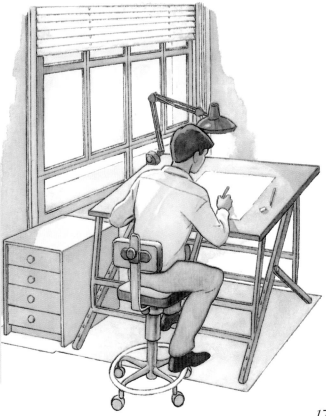

A CERTAIN AMOUNT OF ORDER
Artists have a reputation for being disorganized, but without some order it is impossible to work comfortably. Every tool should have its own place and should be returned to its place after your work session, but do not worry about this when you are working. Concentrate only on your drawing and do not pay attention if, for example, you drop something or if a piece of paper is not in its proper place. You can put everything in place when you are done with your drawing session.

Keeping Work Clean

Drawing materials tend to be "dirty." They stain your hands and of course your paper. As you gain experience, you will learn how to take advantage of mistakes or accidents, which happen almost inevitably while you are drawing. Nevertheless, it is good to take some precautions to help you avoid creating unnecessary problems. Your drawings can be damaged or even ruined by not taking some basic precautions. Wash your hands after each time you use them to blend charcoal or colors; use a piece of clean scrap paper under your hand to protect your paper; and make sure that after you erase no eraser crumbs remain. Don't be overly worried about these things while you draw, however. These precautions will soon become automatic habits that you will not even have to think about.

◆

Taking some basic precautions will help you to avoid problems

◆

Clean your eraser on a piece of paper before starting to work, until it is clean.

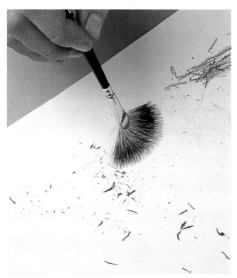

Eraser crumbs should be brushed off before continuing your work (a wide paintbrush is helpful); otherwise, your pencil can hit the crumbs, which can divert your line.

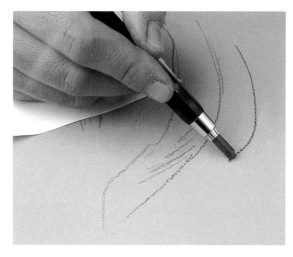

Place a piece of clean scrap paper under your working hand so that you do not smudge what you have already drawn.

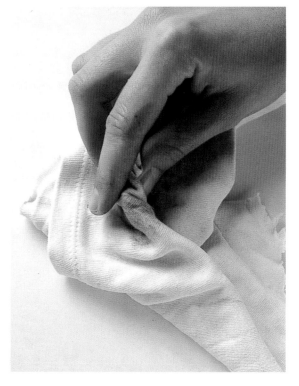

When you draw with charcoal, clean your hands often so that you do not leave any unwanted marks on the paper.

First contact with the materials

Drawing techniques depend on knowing how to use the materials. Drawing with a pencil is not the same as drawing with a sanguine chalk, nor is drawing on smooth paper the same is drawing on rough paper. Each tool requires unique treatment and handling.

All artists have their preferences as to what materials they use and when they use them. A portrait, for example, will not turn out the same if it drawn in pencil instead of charcoal — a pencil creates subtle marks, a softer tone, while charcoal makes darker marks, which gives a stronger impression. Each tool gives its own characteristic energy or softness to the work. For this

◆

Each tool lends a unique character to a drawing, depending on the medium's inherent vitality or smoothness

◆

reason it is absolutely necessary that you become familiar with the drawing mediums before you start anything. Besides, it is fun to sketch, blend, and combine different mediums, test their effects on various papers, etc. Don't worry about the drawing itself for the moment, but just experiment.

You'll discover that some mediums are softer than others. For example, charcoal spreads very easily over paper; graphite is oily and seeps into the grain of the paper more than any other material. You'll learn how erasing pencil marks differs from erasing sanguine chalk, and how the texture of different papers affects your drawing. Experimenting does mean using up your materials, but it is well worth it. Drawing materials are not very expensive and you should not be stingy when using them or worry about using up a few sheets of paper or a stick of charcoal. Use lesser quality paper or brown wrapping paper for the beginning exercises; the results will not be exactly the same, but the practice with the materials will be very helpful in the future.

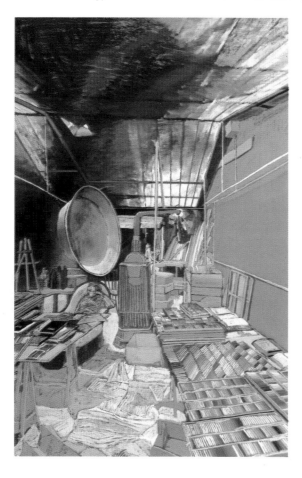

Sam Szafran, Workshop. Private collection. Each artist has his preferences and develops his work using a medium that works the best for him. This painter, for example, used chalk and pastels. Before you decide which materials you feel the most comfortable with, experiment with all of the different mediums and get to know their potentials.

The Characteristics of Graphite

Graphite comes in sticks and, of course, is available in pencils. The characteristics of graphite can be summarized as follows: you can get subtle gradations of tone from dark to light and vice versa, by means of using leads of various hardnesses; even, dark zones without any traces of line strokes when the flat side of a stick is used; and clear lines when the pencil is held upright and the point is very sharp. Drawing with graphite enables you to play with light and darkness to the maximum while also letting you obtain an excellent definition of contours, profiles, and small details.

We will take some sections of the large drawing shown on this spread and explain the particular techniques that were applied to create it. We suggest that you try these techniques out on a piece of paper while you study how each one helps to create the overall effect of the drawing.

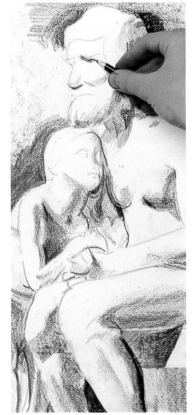

By holding the pencil near its point, you are able to have good control over the line, and you will be able to see the effect you are trying to achieve. Here the eyelids are being outlined by a dark line. These kinds of details are always applied after the general shading has been established.

Drawing with the pencil held normally is good for making small drawings that are mainly lines.

Here the flat side of the lead is being applied to the paper by holding the middle of the pencil without pressing too hard. As you can see, the result is shading that appears blended, without any traces of lines.

The illustration to the left shows how to hold the pencil to draw freely, to make soft shadows or groups of lines that do not require a lot of precision. Drawing like this gives you greater control of the whole work and of the shape of the long lines.

The illustration at right shows how to hold the graphite stick when you need to use the entire stick to shade, without showing any lines. This position is also used to draw straight lines, by moving the stick in the same direction it is held.

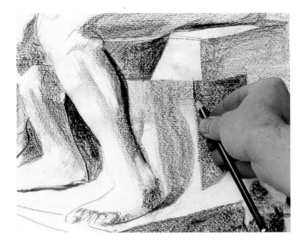

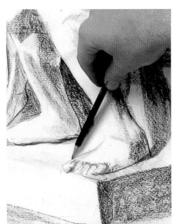

By holding the pencil almost at its end, you have the least amount of control, but you can, however, obtain soft and smooth shading because the lead barely touches the paper, which this section of the drawing needed.

An outline separates two shaded areas in this photo. The pencil is held close to the point, so that there is greater control over the line. The flat side of the lead is applied to make a straight line.

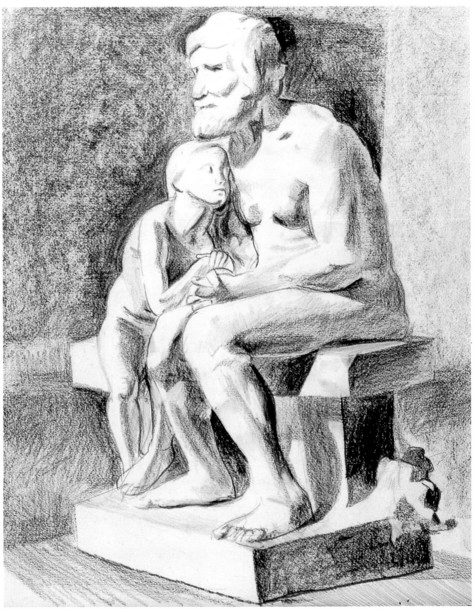

All of the possible techniques of pencil drawing were used to make this drawing. Normally, only a couple of these are used, done with one or two hardnesses of lead at the most, but a variety of effects were possible due to the drawing's large size.

Colored Pencils: A Painted Drawing

The ways of holding graphite pencils and the effects that they create also work for colored pencils. The only difference is in the results: where before we created shadings and tones of grays with the graphite pencils, we now will create painting effects by mixing and overlapping colors. Even though the colors of pencils aren't actually mixing, when one color is applied on top of another color, you have the visual effect of a new color that is almost like actually mixing two colors. As mentioned earlier, it is good to buy a set of colored pencils that has a wide variety of colors so that you do not waste your time by constantly overlapping colors to achieve a particular color that a big set might already have. These two facing pages will explain all of the methods that pertain to drawing with colored pencils.

Direct mixing of colors on the paper, which is always difficult with colored pencils, can be replaced by cross-hatching with two or more colors in different directions.

How much pressure you put on the pencil determines the color's intensity. This allows you to play with the paper's white color when you are lightening color tones, leaving some sections white or transparent according to how intense you would like the color to be.

WORKING WITH COLOR RANGES

The chromatic variety of a colored pencil drawing is achieved by using many distinct tones and not by prior mixing of a limited number of colors, as is normal in other color techniques such as oil and watercolor. You have several pencils for each tone (4 or 5 greens, a few blues, several reds, etc.), thus there are many mixtures and the drawing communicates the color range of the subject.

You can create evenly shaded areas by cross-hatching in different directions. Apply strokes evenly so that the areas do not seem broken up.

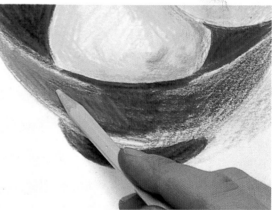

Light gray colored pencils are very useful for lightening tones. They mix the color into the white paper. This effect can be achieved with a white pencil also.

Before you begin a drawing with colored pencil that will require a lot of work, study your subject and decide on the colors, or ranges of colors, that you are going to use and combine.

This drawing used all of the typical techniques of colored pencil drawing: shading, overlaying colors, and hatching.

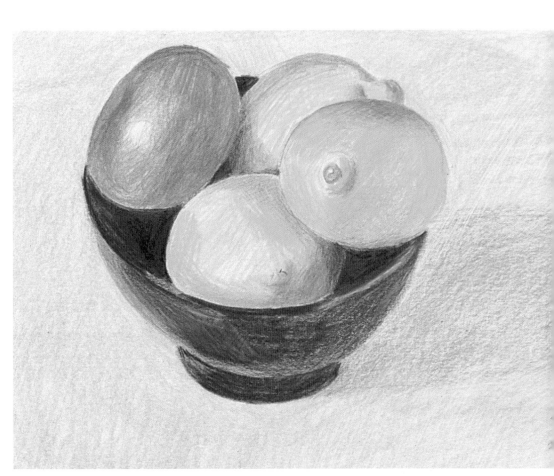

Another interesting aspect of gray colored pencils is that they diffuse lines and unify color zones. Gray hardly affects the dominant color tone and blends with the colors very well.

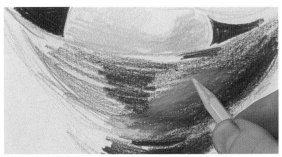

By applying the flat side of the lead on the paper, you will make nice colored zones without any visible traces of lines, which will emphasize the paper's texture.

Direct Mixing, Optical Mixing, and Cross-Hatching

Directly mixing a color consists of drawing over a previously laid down color, pressing until both colors are blended into a mixed color. This does not always give the best results. It is often better to do optical mixing. This is done by softly drawing one color over another to create a glaze — a colored film that gives the effect of a mixture. Put down the darker color first and then the lighter ones on top. Optical shading works better when you are working with primary colors (yellow, red, and blue) than with gray, dark, or neutral tones. Another alternative is to use cross-hatching, which consists in crisscrossing different-colored lines that, from a distance, appear to be mixed. This technique takes longer than the others.

These two samples show the effects of an optical mix: it only works when you place the lighter color on top of the darker color, as shown below right — never the reverse.

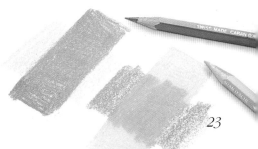

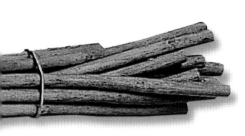

Charcoal sticks are carbonized willow branches. They are sold in packs or individually.

A Piece of Charcoal

A piece of charcoal is good to use for a large-format drawing. Charcoal is an extraordinarily direct medium. You can draw with the entire stick, holding it like a pencil, or you can draw with its flat side. It smudges a lot, but this is an advantage. You can draw the main lines of a subject, along with its shadows, very quickly. Charcoal lines can be erased, blended, and strengthened as many times as necessary. The intensity of the lines can be as dark or light as you like, from dark black to soft grays. If you work on a light-colored paper instead of white, the grays look better and the shading does not appear as crude as on white paper. Charcoal is a fast, easy, and fun medium to work with.

Blending

You can use your fingers for blending, but blending stumps let you refine your shading. A blending stump is made from a soft paper felt that is double-ended and pointed. The points let you get into tiny areas that a finger might not fit into. Blending stumps spread the charcoal while at the same time diminishing its intensity; they can also blend dark shades into lighter ones without any breaks. When they are loaded with charcoal, use them to directly shade an area.

These are blending stumps in different sizes and hardnesses. The softer ones absorb more charcoal and smudge more; the harder ones spread the charcoal more and are used on smoother papers.

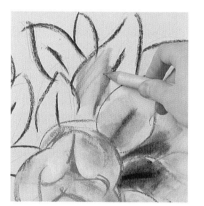

In this photo you can see how the charcoal lines are spread and blended with the blending stump. This effect intensifies when you work directly over charcoal strokes.

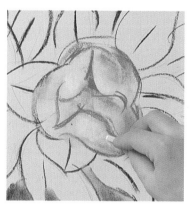

Artists' chalks are used exactly like charcoal sticks, but smudge less easily and do not blend as easily as charcoal. You can make thin lines with them. The side of the chalk frequently is used for big areas.

ARTISTS' CHALKS
Artists' chalks are little sticks of color that are similar to pastels but harder. The most common colors are sanguine (a reddish color), brown or sepia, and white. They accompany charcoal very nicely, especially when they are applied to a cream or buff paper. Because they are harder than charcoal, they outline blurred lines and enhance shadings with colored lines.

Chalks are sold as sticks and pencils. The obvious advantage of using a pencil instead of a stick is the sharpness of the point. The sticks are normally used for large-format drawings and the pencils for small ones.

Fixing Charcoal Drawings

In order to fix a charcoal drawing, you must apply a spray fixative on the charcoal so that it does not smudge or fall off. Spray on the fixative about 12 inches (30 cm) from the drawing, keeping the paper vertical. The coats should be light and sprayed quickly so that the paper does not become saturated. Keep applying the fixative until the charcoal does not smudge when touched.

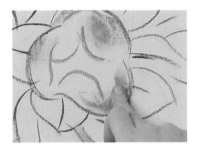

In this photo you can see how chalk strokes can be blended and mixed by rubbing them.

Several blending techniques were applied to this drawing, made with charcoal and a sanguine chalk.

To obtain wide blended zones, first apply the charcoal so that the particles accumulate on the paper. Rub over the area with your fingers or a blending stump.

Rubbing with all of your fingers makes it easy to spread and blend the charcoal over large areas.

YOUR HAND IS THE BEST TOOL

Charcoal can be spread with blending stumps, but the traditional method is the most direct and efficient: use your fingers and the edge of your hand. Dirty your hands without being afraid, and take advantage of the smudges to create soft blends and shades in other parts of the drawing.

Each part of your hand has a function in blending: use your fingers for small details and the rest of your hand for large areas.

Sanguine in the Classic Style

As we have already seen, sanguine is a reddish earth tone. Sanguine chalk is a classic drawing medium that is warmer than charcoal; it could even be said that it is the ideal color to paint feminine themes because it possesses harmonious and soft transitions. Its best results are seen when it is used on colored paper. The recommended colors of paper are: light ochre, cream, pale sienna, light green, and light gray. It is good to try out sanguine chalk on these colored surfaces, because the effects cannot be easily shown in a photograph. Working on colored paper, you have the added advantage of being able to use, along with the sanguine, white chalk to create lights and reflections. In the drawing reproduced here, sanguine and white chalks and charcoal were applied on cream-colored charcoal paper.

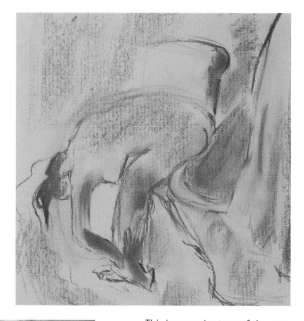

This is an early stage of the large drawing. Notice how the sketch is light with full, broad strokes.

Using the flat side of the sanguine chalk is good if you want to work with the grain of the paper to create textured effects, as was done in several parts of the work.

Notice how applying white chalk on top of charcoal lines creates a light gray that serves to contrast with the human form and outline the contour.

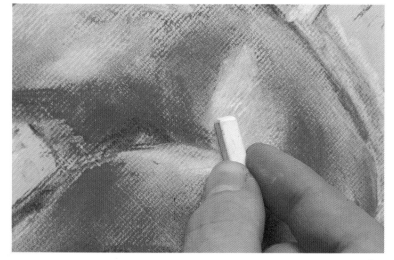

The biggest advantages of drawing on colored paper: not only is the sanguine color strengthened, but also the white, with which we are able to enhance the highlights and light areas of the drawing.

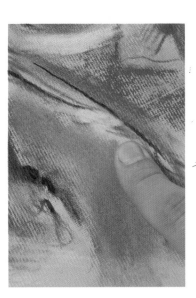

Sanguine chalk does not blend as well as charcoal; nevertheless, blended areas can be obtained by rubbing with your fingers.

The Paper Also Counts

When using colored paper, you must remember that you are adding another color to your drawing. The areas that are not shaded will remain the color of the paper. Cream colored papers are ideal for representing the human body. Shading around the form and leaving the paper's color in the figure will let you express the human flesh color with elegance and simplicity without overburdening the form with unnecessary lighting, shading, and blending. Naturally, you must choose a tone that goes well with sanguine.

This drawing is a sketch that is based on blended contrasts. Realistically detailing the body was not the goal.

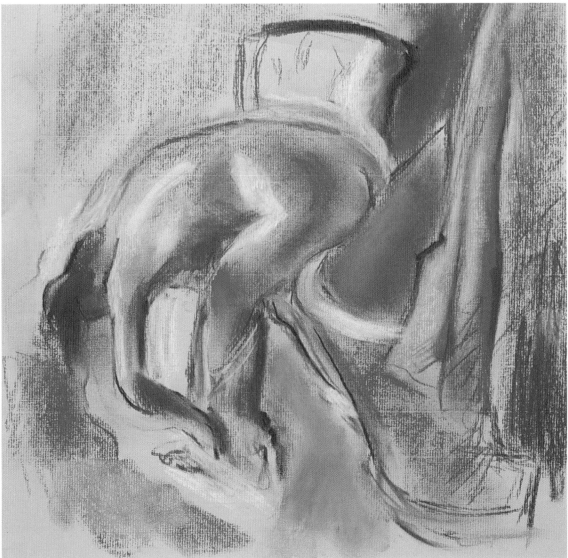

Using Mixed Media

The mixed media technique is a combination of distinct drawing methods that are used in one work. It is an experimental technique that is popular these days. However, not all of the techniques can be combined. Graphite and charcoal, for example, cannot be combined since graphite is oily and charcoal is dry and won't stick to the graphite. In general, whether with painting or with drawing, oily mediums cannot be put under dry mediums. Apart from these, the remaining drawing mediums can be mixed quite well with each other. The work on these two pages combines dry drawing mediums (charcoal, pastel, and chalk) and a wet technique, gouache (opaque watercolor). The accompanying photos detail how to obtain the different effects of form and color.

In this work, chalks, pastels, charcoal, and gouache were used. It is a good example of a mixed media technique that combines painting and drawing.

WET AND DRY
All drawing mediums can be applied over wet areas, if applied carefully. In the work shown, the gouache color areas were first applied; then the shading of pastel lines, chalks, and charcoal was drawn on top. You could reverse the procedure: cover and extend the lines of sanguine chalk with brushstrokes of thinned gouache or water.

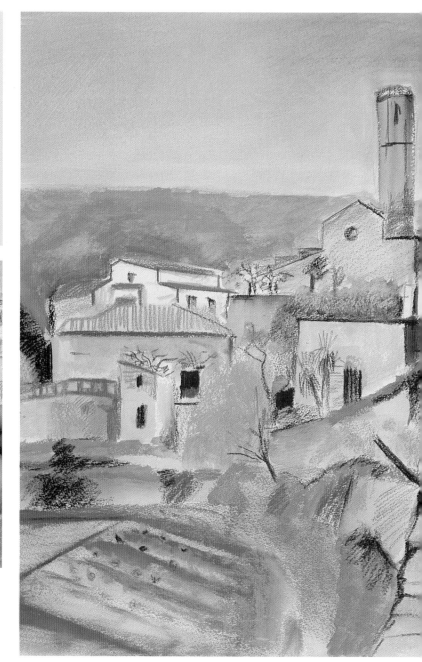

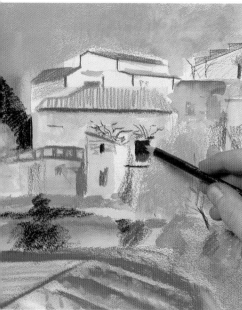

Charcoal pencils create intense black lines that can be used to contrast with light-colored areas, especially if those areas were thinned with water.

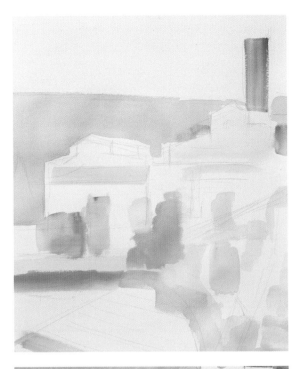

Working with Gouache

Gouache is the one of the most common mediums used in the mixed media technique. Gouache colors can be mixed with almost every drawing medium, whether wet or dry. It is usually used with pastels because gouache-colored surfaces become slightly rough when dry, which allows the pastel particles, as well as chalks and charcoal, to stick to them easily. But you can reverse the procedure, applying watered-down gouache colors so that the pastel or chalk pigments can mix with the gouache. If you use too many combined techniques, you run the risk of overworking your effects. To avoid this, use the gouache carefully; make sure that it is thoroughly thinned with water so that you do not apply thick layers.

The work in its initial stage. The composition has been blocked in with gouache.

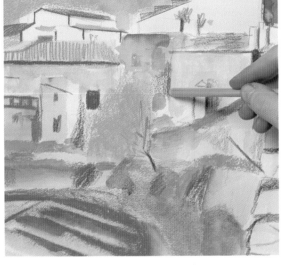

A charcoal pencil or chalk stick helps to outline the blended contours of the gouache.

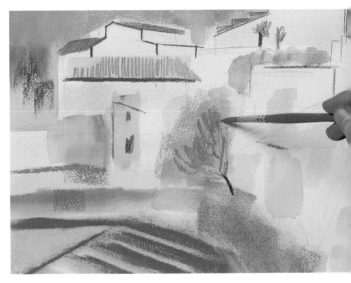

Areas of chalk or pastel can be mixed with gouache, as long as the gouache is diluted enough.

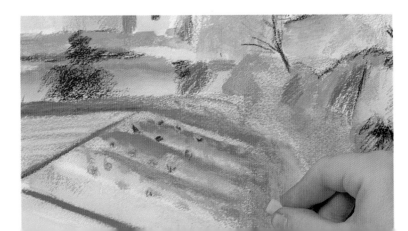

Pastel adheres well to gouache-painted surfaces. It is an excellent medium to use for accenting water-based colors.

Some Easy-to-Avoid Errors

Let's return to the topic of cleaning and caring for your drawings during and after your work. We will mention some common problems that can be avoided — for example, traces of fingerprints on the finished drawing due to carelessness, or folds in the paper due to improper storage. All the advice given here refers to techniques already discussed, and the problems have easy solutions. In the beginning it is normal to dirty your drawings a bit or accidentally ruin them; nevertheless, it is a good idea to take some necessary precautions, as long as they do not interfere with your freedom to work and ease of movement. With practice, you will soon learn to avoid these mistakes without even thinking about it.

Do not erase colored pencil marks unless they are light. This is what happens to your paper when you erase too much.

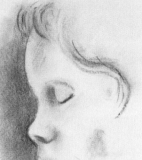

When you blend with your fingers and do not take any precautions, it is easy to leave fingerprints on the drawing.

This can happen if you draw with a hard pencil instead of a soft one before applying charcoal. We erased the pencil marks, but the pencil line impressions remained on the paper.

Always clean the blending stump on a separate piece of paper after each use so that you do not accidentally stain the drawing.

Paper that is not stored properly can become creased or folded. If this happens, it is impossible to get rid of the folds; they will be visible when you blend over them.

When you erase with a dirty eraser, the paper becomes stained; therefore, clean the eraser on a separate piece of paper.

Some simple forms

Drawing means knowing how to graphically represent imaginary forms or real objects. All objects are composed of elementary forms. Therefore, you can represent any object by learning how to recognize the forms or combination of forms that comprise it. We are all capable of drawing these simple forms...

...forms so simple that you do not even have to know how to draw in order to make them. It's enough to know is how to draw a square, triangle, and circle. These are the essential forms that are the basis of drawing. By combining these forms in different ways, almost anything can be drawn, but you must practice drawing them so that you are able to draw them with very few lines, in any position and size.

We strongly suggest you practice doing all of the drawings in this section. You should also continue to practice drawing them on your own by trying to reproduce every object that you see or by mentally picturing each object. One of the advantages of beginning

◆

By combining simple forms, you can draw almost anything.

◆

with simple outlines is that your figures will always retain an elemental aspect of these basic forms, which will give them a certain charm that is, without doubt, worth keeping, even in more elaborate drawings. Beginning with a good knowledge base, you will continue to add details and more elaborate effects to your drawings as you get more skilled. It is easiest to draw these forms with a pencil (a soft-leaded one — 3B, for example), but use whatever medium you like. Keep in mind that you may have to make your drawings bigger than we did if you use a tool that creates thicker lines, in which case the drawings also tend to be larger.

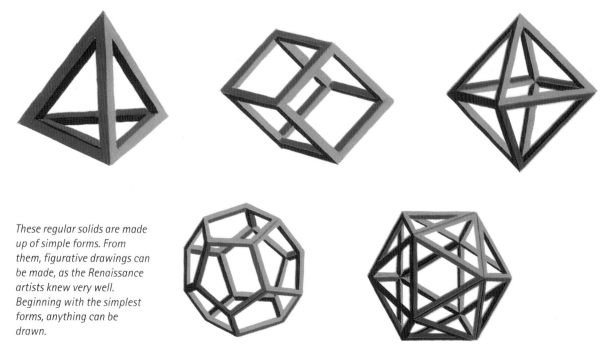

These regular solids are made up of simple forms. From them, figurative drawings can be made, as the Renaissance artists knew very well. Beginning with the simplest forms, anything can be drawn.

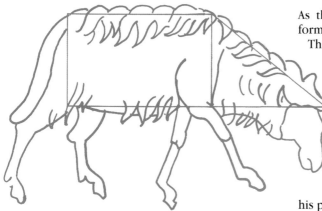

The Purity of Basic Forms

As the medieval artists knew so well, elementary forms have an irresistible attractiveness to them. They are the pleasant side of geometry. No formulas or complicated calculations are involved, just the regularity and harmony of forms. This page reproduces some drawings from the great medieval artist Villar de Honnecourt, who gathered many examples like these in a book so that they could inspire other sculptors and painters. All of the drawings are broken down into simple forms which have an astonishing clarity to them. Honnecourt applied a lot of fantasy on his part, but this is what makes each drawing charming; he also demonstrated that the art of drawing is based on simple and unchanging fundamentals: the basic forms.

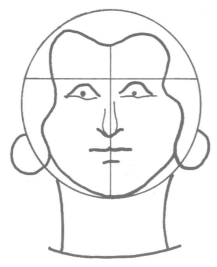

These are some of the drawings by the medieval artist Villar de Honnecourt. They were an inspiration to many artists during his time. The grace and interest of these simple works have not disappeared with time. Even today they continue to be very helpful to people who draw.

A COMBINATION OF FORMS
All drawing is simply the combination of strokes, lines, and areas of color. These lines are more or less complicated variations of basic contours that coincide with the basic forms. Using them as the base, you can create complex forms, figures in motion, landscapes, and all other artistic themes. Once you know how to draw the elementary forms, it is only a question of learning to see them in real life, finding them in your subjects.

Benito Bails, Principles of perspective (1776). This figure is made of cubic forms, which fundamentally are combinations of squares and rhombuses. Another example of the use of basic forms in drawing.

Preliminary Directions

It will be much easier to draw these simple exercises on a large scale, 6 to 8 inches (15 to 20 cm) on each side. You will be able to control the lines better and will be more conscious of any mistakes. Drawing a circle this size is not as hard as it seems. When you get the hang of it, it will be very easy to draw the form on a small scale without the help of a square outline. Our objective is to draw simple forms easily so we can then go on to complex subjects.

Questions of Proportion

To know whether or not a shape is well proportioned, you only have to compare it with another one that you know is correct. Little by little you will not need this help and will be able to determine the correct proportions by simply glancing at the object. While you are drawing, pay attention to the shapes on this page and make any necessary corrections. If you make a mistake, do not make too many corrections on what you just drew, or you will end up not knowing where you went wrong. Instead, start again on a clean piece of paper and keep practicing the exercise as many times as necessary.

The method of drawing an oval is the same as that for drawing a circle; just use an outer rectangle as your guide instead of a square.

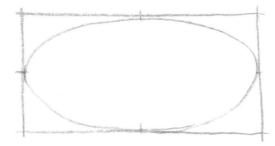

Drawing a square consists of making four lines at right angles. The lines should be of equal length and as straight as possible. Hold the pencil as shown in the photo. The length you make the first line is your guide for the other three lines.

The same kind of square helps to draw a well-proportioned circle. Mark the midpoints on the sides of the square and draw curves between them. You may not get it the first couple of times, but soon the curves will turn into a circle.

Now it is time to draw a triangle inside the circle. This can be done in many ways, but to begin with, try to draw it as shown in the photo.

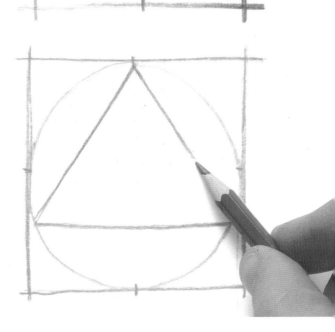

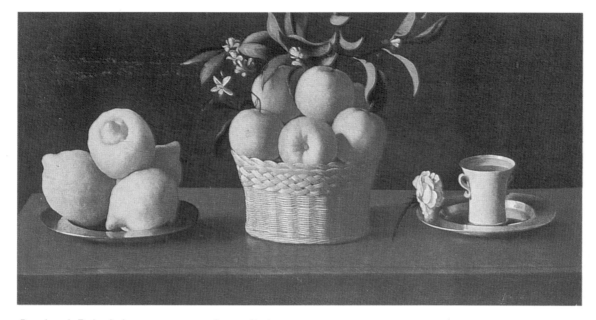

Francisco de Zurbarán, Lemons, oranges, and roses. *Norton Simon Foundation. The purity of the lines and forms of this splendid still life are ideal for our study of the basic forms.*

From Sketch to Realistic Drawing

This wonderful painting by Zurbarán is not exactly realistic, but rather is a stylized representation of reality. The works of this great painter usually have beautiful, pure lines, which make them a perfect starting point for drawing forms and shadows. Try to copy the three elements of the painting (lemons, oranges, and the cup on the plate), using only the geometric forms shown on the previous page. Without even beginning to draw, you will see that this is possible. All the painting's elements (except the leaves) can be reduced to combinations of almost perfect squares, circles, and ovals.

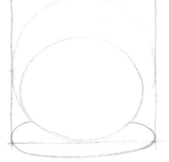

The general outline of the plate of lemons is a circle within a square. The top of the lemons fits in a curve that is about half the size of the circle. The plate is an oval of equal width to the square.

The cup and plate can be sketched by using a rectangle and an oval. Both forms together occupy half of the square. The cup should be centered on the plate, which is the same width as the square.

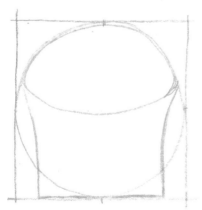

The basket of fruit is based on a roughly triangular shape inscribed in a circle. Beneath this shape, draw a rectangle for the shape of the basket which, if you maintain the correct proportions, extends to the bottom part of the initial square that encloses the circle.

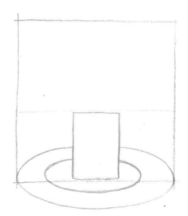

Inside the rough sketch of the plate of lemons, draw four circles that correspond to the four lemons. The sizes are all practically the same, but pay attention to the placement of each circle.

After laying out the shapes, erase the outlines of the square and touch up the lemon forms. In the drawing on the right, some shadows were added to show how the roughly sketched forms coincide with the drawing's forms.

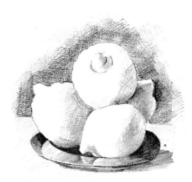

By adding two more ovals representing the mouth of the cup and the rose to the rough sketch on the previous page, you will have enough of an outline to work from to finish the drawing.

In the drawing below, you can notice how the contours of the previous layout have been kept. Only small details and some light shading were added.

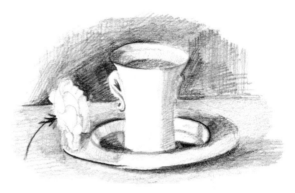

This basic sketch of the fruit basket is very similar to that of the group of lemons. We adjusted the contours of the basket to a convex form so it looked like the one in the painting.

Below is the finished fruit basket. You probably can achieve similar results.

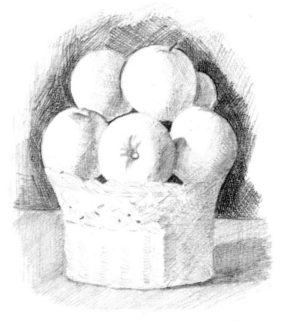

A NEW DRAWING
Another good exercise is to draw all of the things from the painting again, but this time grouped as they appear in the whole painting. It's easy, as they all can be drawn from squares of about the same size. The only distances you need to consider are the distances between the groups.

Nothing is easier to draw than fruit — in this case, a tomato. It fits perfectly in a circular outline. However, you must carefully observe the tomato's profile and try to represent it as accurately as possible.

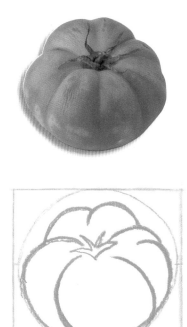

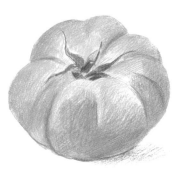

Other Examples

Rough sketches are the basis of drawings. Any real form can be broken down into the simple shapes that we just studied. It is not a question of searching for objects that have a basic form, but rather, discovering these forms in each and every object that we encounter. This is not very difficult once our sight and our imagination get accustomed to seeing the regular shapes that make up real objects. In these next pages, we will show some more examples of drawings that start with these simple forms. These examples begin with the rough shapes, but their finishes go much beyond that. Such finishes are simply a question of practice, which you will get in the upcoming pages. It would not be possible to do them without a clear understanding of the basic shapes that comprise them. The following examples show that a complex subject does not require complicated outlines; it's all about synthesizing forms by reducing them to basic components.

Although the red pepper has an irregular contour, you can easily reduce it to an oval and two circles. The secret is in adjusting the placement of these shapes so that you can create the contour.

SKETCHING AND DRAWING FROM MEMORY
It is very useful to have practiced sketching with geometric shapes we draw from memory, because we do not have real objects in front of us. The shapes give you simple guidelines to understanding forms, and may be memorized easily. They are like an index of correctly proportioned objects instantly at your disposal. This never substitutes for direct observation, but helps in the fluency of execution of any drawing.

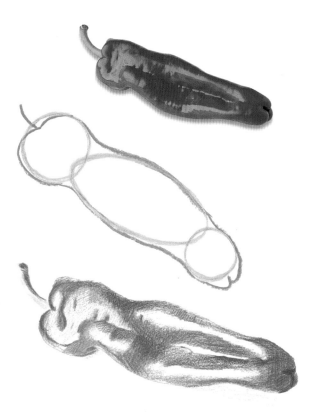

The rough sketch above (middle) is an exaggeration of how the initial shapes should be drawn. In reality, the first sketch should be drawn with much lighter lines so that they do not interfere with the blending and shading that is added in the later stages.

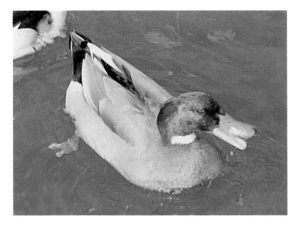

The most important aspect of this animal's sketch is its angle; it is placed diagonally. The diagonal can be made by sketching a square and inserting the oval inside.

Practicing and Drawing

When you have enough practice finding geometric shapes in real objects, it's time to set aside the geometric shapes and sketch a simplified version of the model. If you intend to embellish the model and make it into a fully finished drawing, then your initial sketch must be drawn lightly with loose lines, because an overdone sketch with heavy lines will interfere with later work. Finishing your drawing consists of simply incorporating lifelike details into the basic rough sketch, which is like a builder's scaffold. Once your drawing is done, the sketch won't show, in the same way a scaffold doesn't show when a building is completed.

We are now going to try to draw an animal whose form appears difficult at first sight, but, as you can see, its sketch is just as simple as those of the other studies we have done so far.

After the sketch above, it is very easy (with some practice, of course) to establish the contour of the duck and then to draw the details of its plumage.

FROM LESS TO MORE
When you want to make a detailed drawing, no matter what technique you decide to use, the initial outline should be drawn with very light lines so that they don't cause a problem later on. You can see how the charcoal lines are light in the beginning (near right), when the helmet's basic form is drawn. After adding highlights and shadows, the lines are made darker and the initial sketch disappears beneath successive applications of shadows and texture.

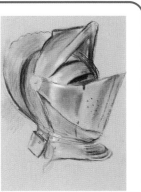

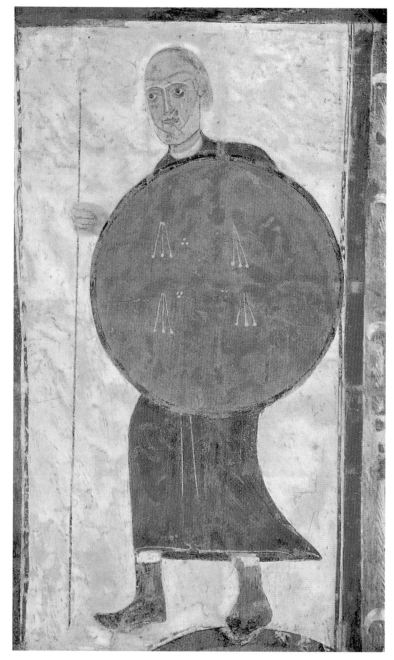

Catalán fresco (12th century). Prado Museum, Madrid. Apparently the artist that painted this had a basic understanding of drawing. The clarity of the simple forms makes this fresco a good example of artistic expression.

The Art of Simplicity

Rough sketches and outlines are used to begin a drawing that will end up with all the details needed for a realistic drawing. However, if these rough sketches have been drawn well and proportioned well, they can be perfectly valid drawings in themselves.

What we understand today as realism was an unknown concept to the world of drawing and painting in earlier times. No one then expected to see an exact reproduction of reality in a piece of artwork, but, instead, they expected to see a clear and convincing piece that somewhat resembled its subject. The warrior in this illustration is part of a Roman fresco from the 12th century. The purity of the forms and the strength of the whole work are based on a perfect geometric model. The lesson this work teaches us is to always begin with the most basic and general forms and then advance to the details — not all of the details, only some significant ones which complement and enrich the forms in the composition, and which fit into the general design.

FLAT FORMS

Rough sketches are always made with regular, flat forms that do not show perspective or depth. Although depth is a very important aspect in drawing, three-dimensional effects are not needed in order to create good art. There are many examples of great artistic works that are completely flat, from Egyptian and Oriental art to beautiful medieval European work.

A little perspective

Perspective can sometimes be a bit cold and technical when studied extensively, but by applying some of its main principles and learning some ways of using it, we can easily solve problems that arise when we are drawing a building or other subjects with vanishing points. Here we cover only the basic principles of perspective.

Perspective usually is not particularly fun for artists. At first it appears too calculated and technical instrument, almost like science instead of art. The idea of sketching with a T-square, set square, and drawing compass, taking measurements, and calculating distances is not very attractive to some. Nevertheless, perspective is not all that complicated. It is based on some very simple, basic rules, which are consistently used and which require only a basic understanding of their essential concepts for their use.

What is the importance of perspective? It is relevant when understood as a method of representing distance in a realistic way. But, when understood as a resource among the many means of expression an artist has, it plays a more or less important part, depending on the subject to which it is applied. Perspective is not used in a portrait and rarely in a still-life, but it is used to prepare the sketch for a landscape, especially an urban one. It is extremely useful when creating a large panorama with elements that repeat themselves (e.g., a street lined with trees, houses, or figures), or when a landscape has many angles and flat surfaces. In such cases, it would not be possible to picture the subject without a little understanding of perspective. The trees appear smaller in the distance, but how much smaller? The façades are less visible and more angled far away. But how do you draw them? These questions have easy answers once we understand the basic concepts of station point, horizon line, and vanishing points.

Perspective is extremely important when you have to draw landscapes, especially urban ones.

Leonardo da Vinci, Study for the adoration of the Magi. *Uffizi Gallery, Florence. This marvelous drawing reveals an exhaustive study of perspective applied to an architectural space.*

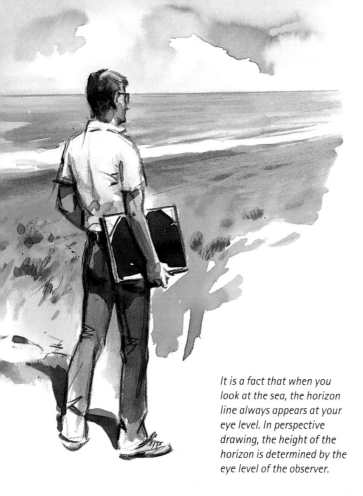

The Horizon Line

The first essential concept of drawing with perspective is the horizon line. The horizon is always in front of you, at your eye level. When you look out at the ocean, the horizon is where the water and sky meet, at your eye level. This definition is true if you are sitting on the beach, or lying on the beach, or resting on the sand dunes. In fact, even if you are lying on the ground, the horizon is always at your eye level. The accompanying illustrations show this clearly. The horizon is fundamental for drawing in perspective. It is the reference line for all representations of depth. Although it is not usually visible, it has to be considered when drawing a perspective view, because the final appearance of the drawing will depend on it. As a result of the height of the horizon, the drawing will appear as if seen from above or from below. Drawing in perspective begins once we draw the first, and most important line: the horizon line.

It is a fact that when you look at the sea, the horizon line always appears at your eye level. In perspective drawing, the height of the horizon is determined by the eye level of the observer.

The horizon is always at your eye level. For example, you fall to the sand; the horizon line moves down and still is at your eye level.

THE STATION POINT

My station point (or viewpoint), as you probably have already guessed, is the place from which I am observing the landscape or whatever I am looking at. It can be very low if I am at ground level; on the other hand it can be very high if I am high on a mountain. In any case, the height of the station point always coincides with the level of the horizon. This is another simple but basic concept we must remember, because all representation of perspective in our drawings depends on the correct application of the idea of station point.

The Vanishing Point

Another basic concept that sounds familiar is the vanishing point. This is always situated on the horizon line. The vanishing point is the place where parallel depth lines that are perpendicular to the horizon converge — lines such as the sides of a path that unfolds in the distance, electrical lines on each side of the road, or the receding walls of a house, seen from far away. They are shown in the two illustrations on this page. The place of the vanishing point on the horizon depends on the level and location of your station point. So, if you change your station point, the vanishing point moves with you. In the real world, vanishing points are constantly changing, but in terms of executing a drawing in perspective, the vanishing point should be determined at the very beginning and remain the same throughout the drawing.

The easiest way to see that depth lines meet on the horizon at eye level is to stand in the middle of a road and observe how the edges project and converge towards a specific point on the horizon.

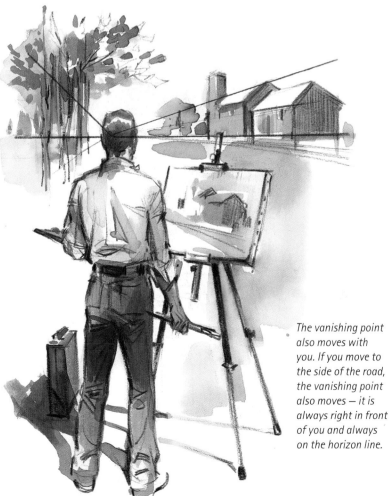

The vanishing point also moves with you. If you move to the side of the road, the vanishing point also moves — it is always right in front of you and always on the horizon line.

PERSPECTIVE: AN IMAGINARY REPRESENTATION

As we have said, parallel lines meet at the vanishing point. But where are these lines in reality? They are not there. We invent them. Imagine that the side of the house is extended to the horizon and that the path is straight and also extends to the horizon. With this exercise of imagination we can draw the correct angle of the façade of the house, the precise narrowing of the path or railway, and the decrease in size of every dimension. Perspective is an imaginary construct that helps us to represent a real effect: the depth of space.

One or Two Vanishing Points

Sometimes we can have more that one vanishing point. We need only one when we draw train tracks that are in directly in front of us, or a house whose façade parallels our line of sight. But when we look at an object from an angle — a house from one of its corners, for example —we see that the lines of one of its sides run to one fixed point on the horizon while the lines of the other side recede towards another point. If we were to stand in the middle of a crossroads, one road stretches away to the right and the other stretches toward the left, each one going off into the distance to its own vanishing point. If there is only one vanishing point in a drawing, you have parallel perspective, but if there are two vanishing points, you have angular perspective. Study how the two drawings below were done and you will see that their construction won't cause any problems.

In these two sketches, you can see the processes of developing a cube in parallel perspective (left) and angular perspective (right). Both of them can be done without using special equipment (except for a ruler). For parallel perspective, draw a cube that projects onto a single vanishing point. To create angular perspective, the cube is projected onto two vanishing points.

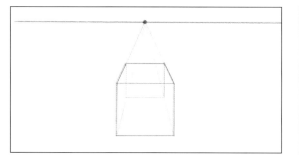

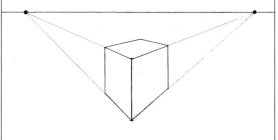

THE HEIGHT OF THE HORIZON LINE

When it is time to draw in perspective, try not to draw the horizon too high or too low; either way will distract from the subject. In the first case, you will have a bird's-eye view of the drawing, while in the second case you will have too much of a ground-level view. The best place to draw the horizon is somewhere in the middle zone of the paper.

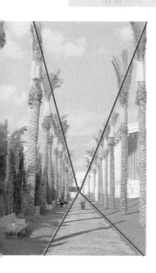

Here is a typical subject that requires a little knowledge of perspective to draw, even if just a basic understanding. It has a single vanishing point and parallel perspective that is easy to establish.

Observe how the converging depth lines were used to organize the drawing's perspective. Perspective solves the questions of how to evenly distribute the objects as well as how to proportionally reduce their sizes based on their distance from the foreground.

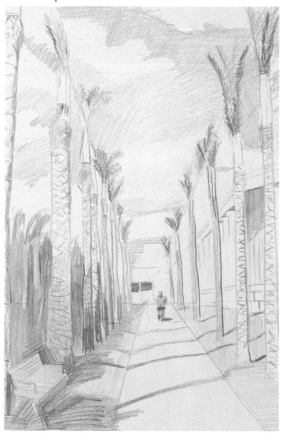

The Unseen Vanishing Point

Most of the time, the vanishing point is not easy to find, and even if it could be found, it falls outside of the paper's margins. Usually, we just draw what we see, without worrying about perspective. But if there are problems of distance and object size, it is very important that we study the subject and look for the converging depth lines and the vanishing point (or points) towards which they move. Where parallel perspective is concerned, the vanishing point can remain outside the drawing, but this does not mean that we can ignore the projection of the principal lines. In the images on this page, we cannot see the vanishing points. However, when they were being drawn, the direction and the slant of the converging depth lines were very carefully considered.

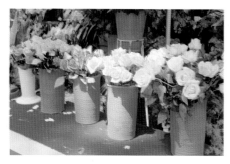

At first glance this appears completely devoid of perspective. But, in reality, there is two-point perspective. While the table's lines recede towards a vanishing point outside the right margin, the depth lines of the vases go towards a vanishing point at the left.

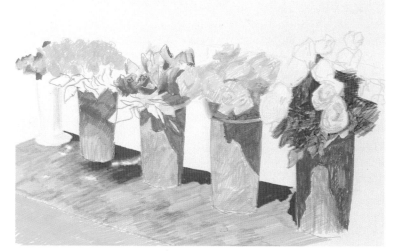

MORE THAN TWO VANISHING POINTS

It is worth mentioning that there are perspectives based on three vanishing points. They usually deal with things viewed from very low down or from very high up, in which case the objects not only diminish towards the horizon but also project towards the sky or towards the ground. Skyscrapers seen from very high up or from ground level are a good example.

In the drawing above, we do not see the converging depth lines, but the placement of the vases and their shadows have been done with clear awareness of two-point perspective.

Nothing indicates the establishment of perspective in this drawing. Nevertheless, to draw the palm trees' trunks and their positions in reference to the ground, a perspective plan was needed — depth lines that move toward the paper's right margin.

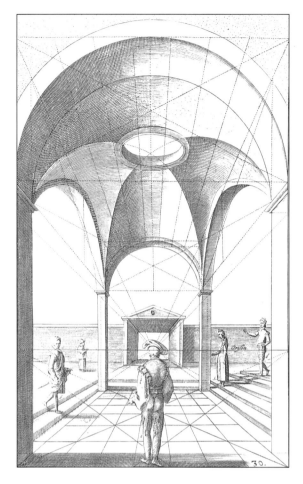

When Art and Perspective Went Hand in Hand

Nowadays draftsmen and draftswomen, designers, and industrial designers are the ones who work with perspective the most. Not many fine artists feel the same passion for perspective that the great artists of the Renaissance and the Baroque did. It is not that artists of today are negligent or not careful with their work; it is just that perspective is not such a novelty for the creative artist anymore. Nevertheless, every artist should be capable of correctly applying perspective, since many creative possibilities, along with a guarantee that the work will not have any errors, rely on perspective. In the illustrations on this page, you can see the fervor of artists like Piero della Francesca, who planned this work entirely based on the principles of perspective, or the Dutchman De Vries, who calculated the positions of the figures in his meticulous work using perspective.

Piero della Francesca, Polyptych of Saint Anthony (detail). *National Gallery, Perugia. During the Renaissance, perspective was a huge creative stimulus. Not only did the possibility of creating a realistic work attract painters, but there were new compositional possibilities using this technique.*

To draw is to compose

Knowing how to draw means, among other things, being able to harmoniously arrange the forms on the paper — in other words, knowing composition. A composition should appear natural and spontaneous. But to accomplish this, you have measure, check distances, and decide sizes. With practice, these calculations will become true artistic instinct.

A drawing's composition usually goes unnoticed. Visitors at an exhibit frequently will admire the minute details of a work of art, but rarely do they stop and think about the power of the composition. It is normal when this happens, because the drawing's or painting's composition, when it is good, is not noticeable, in the same way that the props of a play or opera are not the main focus of attention. Composition sustains and organizes the details of a work and gives it an agreeable, attractive, and interesting look.

Many drawing teachers think that although almost everything can be learned from a teacher, composition is impossible to teach. Composition is the manner in which you organize and place the forms on the paper. It has to be done in such a way that the final result appears natural and spontaneous, just as a musician interprets a complicated piece without any apparent difficulty. You learn how to compose by drawing, drawing frequently, by trying new techniques, by making mistakes, by studying other artists, and by learning from your own mistakes.

Something may be said about the size of the subject on the ground, proportion, the picture's format, and the overall harmony of the drawing. These are the decisive factors in any composition, factors that can be studied and applied. Whether the drawing has simple or complex lines, we must choose the objects; consider their width, their distances and sizes; decide what is significant and eliminate what is not; and animate what is lifeless — in other words, compose.

◆

The composition of a drawing or painting, when it is good, is not noticeable, as the props of a play or opera are not the main focus of attention

◆

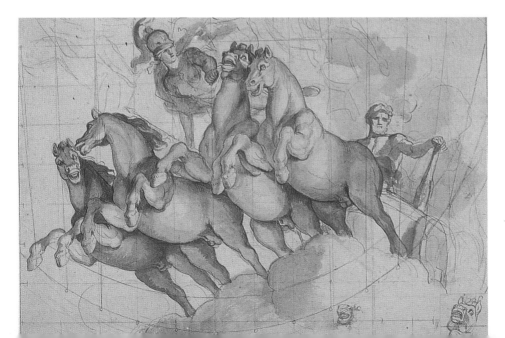

Charles Le Brun, Apotheosis of Hercules. Louvre Museum, Paris. This is a preparatory study for a large-scale painting. You can see the lines that the artist used to organize the figures and compose the scene.

Measurements and Proportions

When we walk through the country or city, when we see fruit or a group of objects while we are searching for a subject for a drawing, and when we consider how to represent these subjects, we are mentally composing a drawing. Better said, we are doing some preliminary composition of the drawing by calculating the measurements and spaces and by sensing what the proportions are in respect to the whole work. When we start to draw, we have to check to see if our calculations work. We compare distances, looking at dimensions and proportions to make things fit together well. To do this, you can use a simple tool for measuring: the length of your pencil. It is very easy. Place yourself before your subject with the pencil in your hand and with your arm extended. The object's dimensions can be measured along the pencil, as shown in the illustration. You will be able to tell if the object's width is half, one-third, three-quarters, etc. of its height. This method of checking proportions is done as you block out the subject's shape on paper.

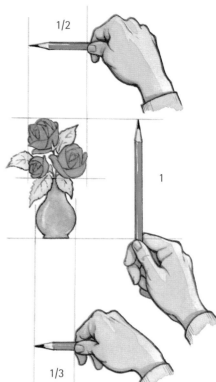

The basic measurements of the object are made with the pencil. Use your thumb to mark the size. It is important to see how each dimension relates to the other. In this illustration, the width of the bouquet of flowers is half of its height. The width of the vase is one-third of its height.

THE PROCESS OF MEASURING

Begin by measuring the subject's complete height, then measure the widest part of it. These two basic measurements will let you establish the overall dimensions of the subject on the paper. These measurements will not be exact, nor should they be, but they allow you to establish the proportions of the parts in relation to the whole subject.

The measurements should be taken by holding your pencil in front of the subject, always keeping your arm extended and making sure not to change your position. If you move closer or farther back, the measurements will be completely different.

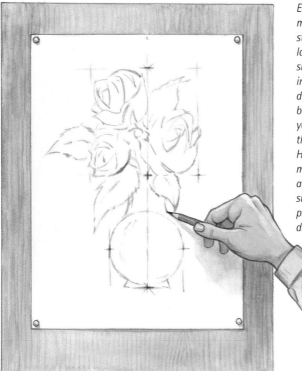

Each of the measurements, starting with the largest ones, should be indicated in the drawing. The bigger ones help you to calculate the smaller ones. Here, 5 or 6 measurements are enough to be sure of a well-proportioned drawing.

Transferring Measurements to Paper

In the illustration at left, notice how the earlier measurements taken for the bouquet of flowers are laid out on the paper. The number of measurements must be enough to place the drawing well on the paper. Usually, five or six general measurements are enough. It is always possible to add other measurements if you can't tell at first glance what the size of a detail should be. This first phase of work should be progressive; the initial measurements are the most important because they decide the overall proportions of the drawing. Make sure that the drawing is well centered and well proportioned in relation to the dimensions of the paper.

The Viewing Frame

To center and frame a subject well, many artists use a very practical tool, made by cutting two L-shaped pieces of black cardboard. With them, we are able to make squares and rectangles of different proportions and use them as a viewing frame to choose a good format for our subject. The proportions of your viewing frame should coincide with the format you think you are going to use — oblong, square, or vertical — so that you have an idea of how the subject will look on paper. Hold the viewing frame before you as shown in the photo, and choose a good view. Do not forget that the view inside the viewing frame will change according to where you stand; experiment with different locations to get the best one.

It is very easy to construct a viewing frame out of two L-shaped pieces of black cardboard.

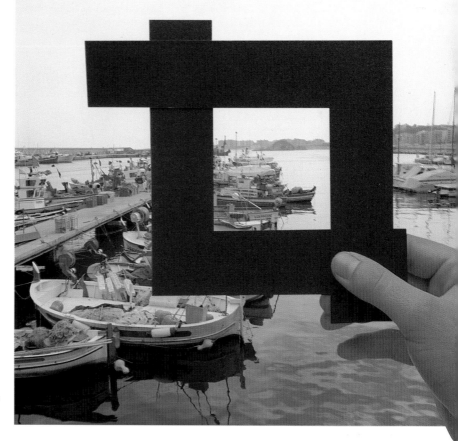

The Image on the Paper

The basic principle for a good composition is that the drawing's dimensions should harmoniously fit both the format and the size of the paper. Any subject, from the very beginning, asks the question, vertical or landscaped (horizontal)? The answer depends on the subject's form, its dimensions, and the relation between it and the background space that will be left blank. There must be a balance between the drawing and the background space. This balance cannot be determined by measuring; it is intuitive. The subject should not be so small that is "dances" in the background, but it should also not be so big that it appears imprisoned by the edges of the paper. The drawing must fit comfortably on the paper without too much extra background space. The best explanation is a visual one. Look at the drawings on these pages. You will see some typical examples in which the image does not fit the paper's format well, and there is one example in which there is a perfect balance between the empty space and the drawing.

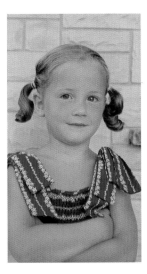

The girl's portrait can be fitted on the paper in many different ways, some better than others. In the illustrations below, you can see some typical mistakes: a drawing that is too small (top left); one too big (top right); and one that is too close to the upper edge (bottom left). The bottom right image shows good placement of the subject.

FIGURE AND GROUND
The relation between the figure and the background ("figure" here means any drawn form) is created from the first lines of a drawing. Be aware of this relationship and seek a balance between figure and ground from the start. The best way to obtain this equilibrium is to take your time in the first phase of drawing, as explained on the previous pages, taking measurements and proportioning the dimensions well. The initial sketch lines of the figure are the most important because at this time we can compare the balance of the figure and background and fix it easily.

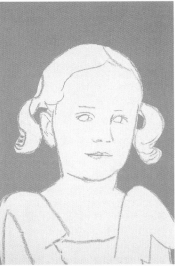

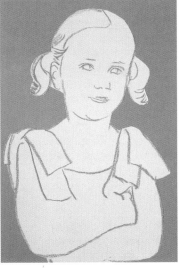

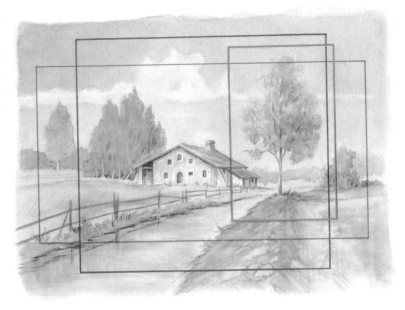

A subject (a landscape in this case) offers many possible compositions. There are many possible frames to choose from, such as landscaped (oblong), vertical, square, etc. Each one of these frames would give rise to an entirely different drawing of a unique nature.

The Frame and Composition

A picturesque subject — whether a landscape, still-life, or figure — offers you many possibilities. Choosing a view means applying limits to a fragment of the chosen reality and then making it your subject. Framing not only means choosing a subject, but also the space that surrounds it in the picture. You have to decide what interests you the most from the infinite variety of forms, spaces, and colors that you see, and mark the boundaries of the composition accordingly.

Knowing how to choose the best view out of the many picturesque possibilities is essential. A big part of the visual attractiveness of the work depends on it, given that every choice offers a unique aspect and emphasis. The photos of landscapes shown on this page are well composed within their rectangles. They are ready to be painted. The rough sketches that accompany the photos show the basic composition lines, which you should always draw first.

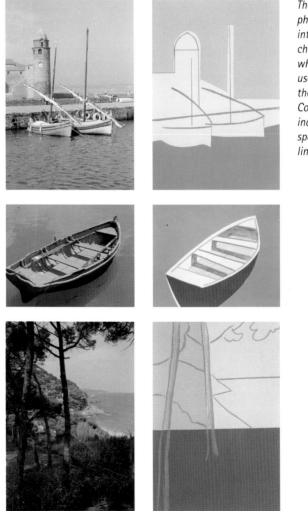

These three photos show interesting choices of view, which can be used as shown in the sketches. Color is used to indicate the space and basic lines.

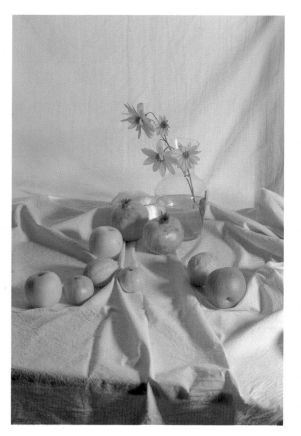

Interpretation

Interpretation includes all aspects of the composition of a drawing. It is based on the freedom that we should always have with any subject. As a general rule, it can be said that interpretation is based on three concepts: emphasize some aspects of the subject, deemphasize others, and get rid of everything that is irrelevant. This relates to size, color, line, form, and light. Applying these concepts depends, in the first place, on the impression that we receive from the subject before us. If this impression is strong enough to make us decide to work with it, then we should express it by emphasizing the essential aspects, toning down those that are not, and eliminating those that are not important or that detract. This all means that, in practice, you must try various compositions until you get the combination of lines and forms that truly have strength and artistic merit.

In subjects like this one, which is quite suggestive in its lines, forms, and colors, free interpretation should prevail over literal reproduction. This free interpretation may be expressed in various drawing and painting mediums.

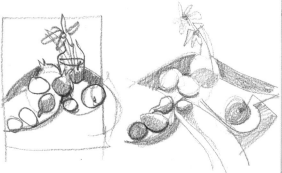

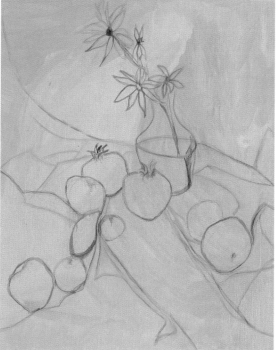

These preparatory drawings perfectly demonstrate, better than any theoretical explanation, what interpretation should be: freely combining elements to achieve an interesting result.

From the earlier experiments, we create a drawing that may be interpreted in any drawing or painting medium.

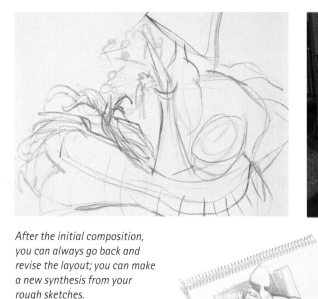

After the initial composition, you can always go back and revise the layout; you can make a new synthesis from your rough sketches.

Sometimes our favorite corners yield very good subjects if we observe them from an artistic point of view, looking for an interesting composition by sketching.

The angles of the flower arrangement and the lamp suggest compositional solutions that move away from a literal copy of the subject. Beginning with this suggestion, multiple rough sketches can be made, letting your imagination run free.

"EVERYTHING IS COMPOSITION"

This quote is by the great French artist Henri Matisse. It has to be understood literally. An artist has to compose and contrast values, sizes, lines, forms, tones, etc. Composition is creating, interpreting reality according to a personal vision, emphasizing what is important, what is essential, and ignoring the minor details. In drawing, complete freedom is legitimate in pursuit of an expressive and visually strong result.

A still-life is a composition in itself; an exercise in organizing elements of different sizes, forms, and colors. A harmonious still-life arrangement is only the start of the work.

Here is a more literal interpretation than the other sketches. It keeps the order and distribution of the objects that are on the table.

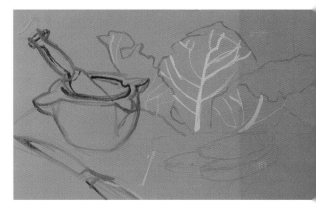

Here is an interpretation of the still-life that establishes the subject simply, respecting the order and arrangement of the objects on the table.

Layout and Composition of a Seascape

This simple example shows some of the fundamental aspects of composition. The subject is a scene that is backlit, so the forms are reduced to silhouettes. We are not going to raise any questions except the main ones about the picture rectangle, proportion, and composition. Charcoal lines and shading can solve everything. The only problem is where to place the lines and shadings to create a correct and harmonious composition. We will see!

MATERIALS
- Charcoal stick
- Charcoal pencil
- Stick of white chalk
- Cream-colored charcoal paper (Canson or similar)

1 These thick charcoal lines correspond to the measurements we made of the subject. The length of each line, their angles, and the distances between them are based on careful mental measurement. Defining the composition, we have done the most important part of the drawing.

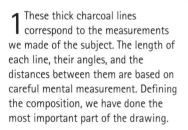

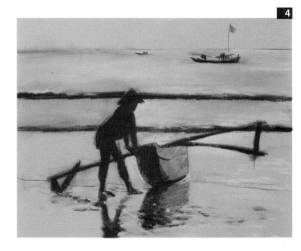

2 Beginning with the basic rough sketch that we did above, it is rather easy to define the forms of the figure's silhouette and of the boat, since the dimensions are perfectly clear. We do this with a charcoal pencil; it makes much finer lines than a charcoal stick.

3 We have blended the background and are now touching up the wave's shadows so that the background does not remain too undefined; likewise, the silhouettes of the figure and the boat were darkened with charcoal pencil.

4 This is the final result. We added some touches with white chalk to create the light areas. This is not necessary, but it helps to round off the finish and create the effect of a late afternoon's light. The object of this exercise is to understand the importance of a good choice of view.

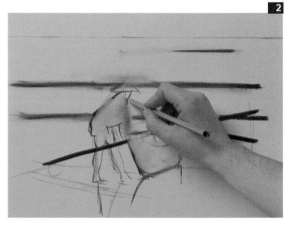

SKILLS

♦ Composition ♦
♦ Measurement and proportions ♦
♦ Framing ♦
♦ Blending ♦

Light and shadow

Shading is the most direct method of representing the volume of real objects. In addition to volume, space, the sensation of depth, and atmosphere are concerns that are associated with shading.

Shading is one of the most essential facets of drawing. There is nothing wrong in solely drawing with lines, contours, and silhouettes without any indication of what they enclose, but volume, whether we like it or not, is what adds realism to the representation. It is what gives body to the objects and figures as well as making them appear close to us. No one who draws can be unaware of methods and techniques of representing volume. Volume can only be obtained from shading, which shows the effects of light on objects.

When we have a good understanding of what shading is and how to do it, we can apply this technique to our drawings so that they appear truly convincing.

The general idea of shading is simple: it deals with a progressive transition from light to dark tones and vice versa. This basic idea has different applications according to the type of technique that is used. In this section we are going to consider the possibilities for each of the drawing mediums in-

No one who draws should be without the methods and techniques of showing volume, by which it is possible to add realism to drawings

volved in shading. In each of them we talk about the importance of the value and the level of light and shading — this is the essential concept. Once that is understood, it is very easy to draw correct shading with charcoal, sanguine conté crayons or chalk, colored pencils, or pastels.

The topic of values in shading brings us to the threshold of painting, since the values of shading are tones, and knowing how to organize tones is almost the same as organizing colors.

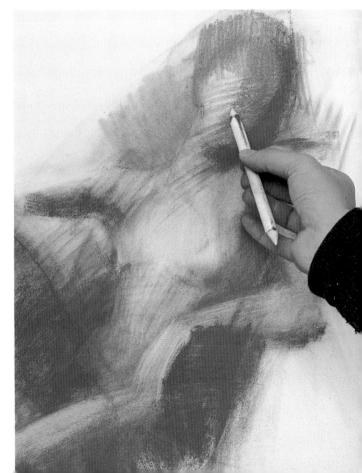

Shading is an essential aspect of drawing. Thanks to it, we are able to portray volume, plasticity, and life.

Shading: Values

Shading gives volume, defines an object's shape, and creates a feeling of depth. All this is achieved by representing light and shadow on objects. This representation always depends on the drawing medium used. It is not the same to shade with charcoal as with pastels; some mediums are more flexible or more subtle than others, or more emphatic, allowing for greater contrast between light and dark. The differences among mediums are always about values and the gradation of tone. Values, in effect, are different levels of light and darkness. For pencil and charcoal we are concerned with levels of gray, and for the other mediums, we are concerned with the different lightness or darkness of color characteristic of the medium used. What all of the techniques have in common when it comes time to shade is the possibility of getting transitions from light to dark or soft to intense that let us represent shadows.

1 The first drawing shows the area's limits that correspond to different values of shadows. We begin the shading with a medium-hard pencil and use light pencil strokes.

2 After the medium-hard pencil, we now take a soft pencil to create the darkest shadows. It is important that the transition between the values be smooth so that the object's surface will appear round.

SHADING WITH PENCIL

Everything about levels of shading can be studied with pencil shading, which is possibly the easiest to use as a guideline for the shading techniques for the rest of the drawing methods.

By using pencils with leads of different hardnesses, it is possible to create a large range of values, from very light grays to almost black shadows. The images on this page show the shading process for a cylinder, on which we previously indicated the area where each value of shading will go. The values used are also shown below these words and offer a wide enough range for the majority of pencil drawings.

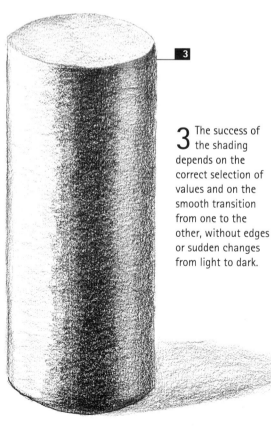

3 The success of the shading depends on the correct selection of values and on the smooth transition from one to the other, without edges or sudden changes from light to dark.

SKILLS

◆ Values study ◆
◆ Pencil shading ◆

Values with Shading or Line

When you are drawing with pencil, the lines have a very important function on the page, since they are one of the few expressive means available with this tool. The function of the lines varies, depending on our goals. Used to add volume to your work, lines do not give results as smooth and perfect as those gained with shading, but they allow you to do more spontaneous, freer, and more energetic work that is typical of sketches or quick studies. Both options are correct as long as the distribution of the values of light and shade is well expressed and the volume is correctly achieved. It's common to use a combination of pencils of varying hardnesses for shading; for line work, it's logical to use only one pencil, usually a soft one.

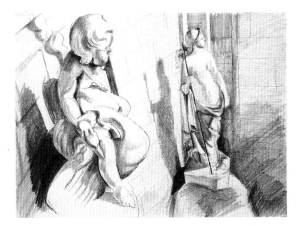

This is a drawing that was enhanced with hatching. We used a regular pencil of the kind usually used for writing and two soft pencils.

This was a quick study in which there was not enough time to do shading. Instead, hatching with light lines was done with a soft pencil, which was more than enough to describe the form and volume.

CHOICE OF PENCILS

Working with the correct kind of pencil is important, but don't obsess about it. It is good to have soft pencils at hand, which draw thick, dark lines. Hard pencils are used only on certain occasions. It is good to develop the habit of working with dark, clearly visible lines that show a strong and clear intention. Apart from that, soft shadows can always be obtained with soft pencils, as long as we draw lightly. If we use hard pencils too much, we will only indent the paper's surface without making any really dark lines.

Shading and Values with Charcoal

Charcoal is the easiest medium for shading. With a little practice, there is nothing that is more pleasing or fun than making quick smudges here and there, blending, reapplying smudges, erasing, etc. with charcoal. A charcoal drawing is established with very few lines and may be shaded with a few well-distributed smudges. The result can be either very free or very controlled, according to the needs and character of the drawing, and the gradation of values can be either very extensive or more limited, like pencil shading. On the other hand, shadows with charcoal usually require blending, since it is hard to go from less to more intensity of shading working only with lines. The shading process is much more direct and less methodical than pencil shading. You first shade the darkest areas and then blend the smudges, thinning them as you go towards the lighter areas.

GETTING RID OF THE LINES

If you would like to do charcoal shading in which the lines completely disappear, the charcoal paper should be of high quality, with a texture that is not too smooth, like Ingres or Canson. Papers with a smooth or fine surface limit shading, and the lines remain engraved in the paper and visible (often the charcoal scratches the paper).

The texture of paper designed for charcoal drawing holds the smudges and assures the darkness of the shadows. In the accompanying illustrations, you can see the transitions from light to dark without any traces of lines.

3 We blended the marks, working from light to dark, leaving the lightest areas untouched. You can see, as a final touch, that we sharpened the contour by erasing the sketch lines on the outer edges of the drawing. Below we give the usual range of grays that are used with charcoal.

1 To show how to shade with charcoal, we are making a drawing of a desk lamp. The preliminary sketch should be very simple so that the lines do not interfere with the shading.

2 We made intense dark marks that are close together where the darkest shadows are. Do this with assurance, pressing hard on the charcoal stick.

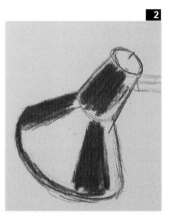

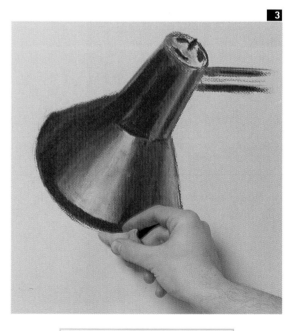

SKILLS
◆ Values study ◆
◆ Shading with charcoal ◆
◆ Blending ◆

Blending: Hands or a Blending Stump?

There is no categorical answer to this question. Your fingers and a blending stump can both be used, but the results will vary depending on which you use. Blending with your fingers is, without doubt, the most direct; the contact with the paper and the control of the shading are much better. On the other hand, the blending stump offers a more perfect finish, more subtle and homogeneous shading, and above all else allows you to control the limits of the marks better because of its point. Maybe the best answer is to use your fingers for more general shading and the blending stump for the details.

Your fingers are the best tools to blend with. The direct contact with the paper gives you more security in shading. They are the best option for creating intense shadows.

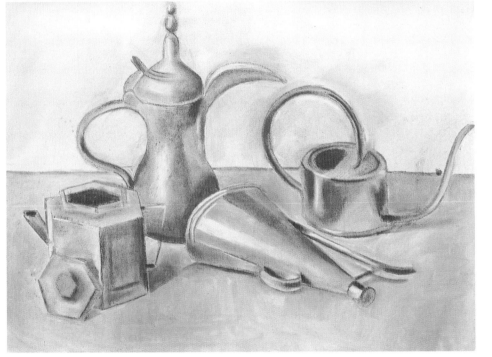

We blended this charcoal drawing with our fingers and also with a blending stump, which was used only in the lightest areas of shading.

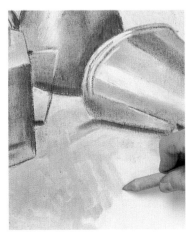

The blending stump is good for surfaces that require a less intense and lighter treatment, and where it's important to stay carefully within the drawing's lines.

ALWAYS STUDY THE VALUES

Blending enables us to create volume easily, but sometimes the drawing may turn out blurry and seem to lack precision and definition. To avoid this, it is good to have a clear conception of values, light and dark areas, and the contrast between them. It's necessary to enhance these contrasts; if we blend everything systematically, without paying attention to the differences of value in the subject, the representation of the volume will be weakened.

Values and Shading with Chalk

Artists' chalks are similar to pastels, and are used for making shadows as well as lines. A typical chalk drawing uses black, white, and sanguine for the base; however, is it common to work with other colors, as well as to combine them with pastels to obtain a range of colors. Used like hard pastels, chalks adapt well to monochrome work as well as color. They blend well together in ways very similar to those of charcoal, so working with their values and shading is similar to working with charcoal. It is a good idea to use a neutral tone of colored paper with chalk, so that white chalk can be used to shape the forms. This way the lightest tone will not be the color of the paper and the values can be extended not only to the darker tones but also to the intense lighter tones. Chalk is the beginning point for drawing with all colors and the step between working in black and white and doing color work with pastels and colored pencils.

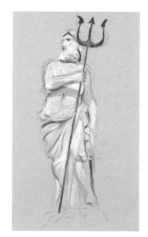

Shading with chalk should begin by simultaneously using the light colors (white) and the dark ones (black or colored chalk). The paper's color supplies the intermediary tones.

Working with two tones always gives you the possibility of making a mixture to create intermediate values — for example, gray shades that smooth the contrast between white and black.

THE PAPER'S COLOR

The color of the paper affects the final result. A good choice of color makes the work easier and enhances the tonalities of the drawing. When you are working with a limited array of colored chalks (black, white, and one other color), avoid paper colors that are too dark, since only the white chalk will stand out on such paper. Generally, the paper colors that usually give the best results are tans, cream or sienna, and light grays with blue, green, or red undertones. In the range of values below, observe how the paper's color is in the middle of the light and dark values.

Below is a range of values that was made using charcoal and white chalk on gray paper. The paper's color is in the middle of the range of values.

Chalk shading gives clear pictorial power and a subtleness that is superior to pencil or charcoal shading.

Chalk, Sanguine, and Pastel: From Values Alone to Color

Black and white chalks and sanguine (an orange-red) are the doorway to working with color. Working with sanguine chalk is very similar to but not the same as drawing with other colors of chalk. Usually sanguine is used on colored paper, and it can be used by itself or can be combined with white chalk to highlight areas. Black and white chalks and sanguine chalk were common mediums that the great Renaissance artists all used. Pastel has a full color range but has all of the qualities of other drawing mediums. The topics of shading and value continue to be present with pastels. However, working with pastels calls for creating dark tones that are not necessarily blacks; they can be sanguine-colored reds, blues, or any other dark color mixed with black charcoal. You constantly have to shade when working with pastels, but you must alternate shading with spots of pure color so that the work acquires the colored range that is typical of pastels.

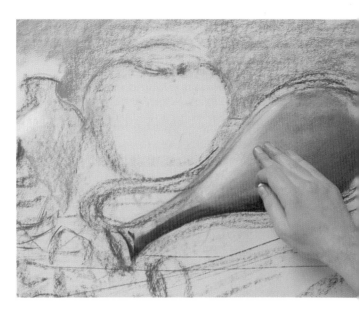

Charcoal is an ideal medium with which to start a drawing with chalk and pastels. In the first phases, the charcoal helps to create values and general shading.

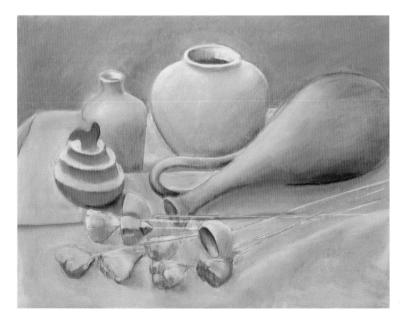

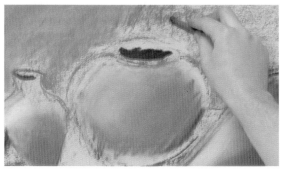

In works like this one, made by combining different drawing mediums, each one of the processes can be seen in the final result, enhanced and blended with the other mediums.

Working with pastel usually involves applying direct colors with little mixing, but it is also possible to add sanguine and charcoal to get different shades.

DIRECT COLOR

Working with direct (unmixed) colors is one characteristic of pastel technique. Pastel work has some similarities to chalk drawing and sanguine drawing, especially regarding shading without using any type of tool except the artist's hands. The question of values, although not as noticeable as with other mediums, is also very important when you use pastels. In fact, the contrast between colors is in itself a kind of contrast of light and dark areas.

Modeling the Figure

Shading the figure merits detailed consideration, because this is the most popular subject for artists and often causes the most problems for beginners. Modeling the figure — the harmonious representation of the body's volume — is neither more nor less complicated than modeling any other subject. It may require more work than others, but it surely is not difficult. Like any other real subject, the figure can be roughly sketched and summarized using some simple forms that we already know: circles, triangles, squares, etc. In the accompanying drawing, notice how the sketch is organized from the simple forms. If you are going to add volume, you must elaborate on these simple forms in order to achieve a three-dimensional appearance. It is not hard, starting with the flat sketch, to get to a second sketch of simple forms, cylinders that are shaded. Once we know how to get to this point, the final drawing is only a question of adjusting the shapes of the volumes, looking at the model.

CYLINDRICAL FORMS AND THE BODY

Although it is possible to use different shapes to conceptualize the figure, the cylinder is the best shape to use. These cylinders have variable widths; they do not have to be perfect. When they are joined together, they will give an approximate image of how the total volume will look once all of the details have been drawn. The cylinders are easy to shade and are a big help in understanding the different parts of the body.

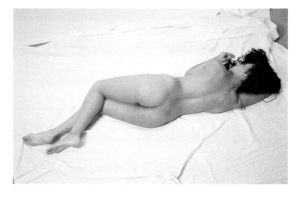

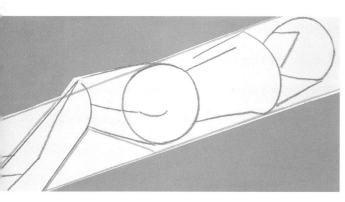

Beginning with the woman's pose in the photo, it is not difficult to make a rough sketch (above) using flat shapes. We used a similar method earlier (pp. 34–37).

From the previous sketch, we move to this rendering based on cylinders. The most important aspects of the drawing are the proportions of the parts and the harmonious distribution of the lights and shadows.

The finished figure, with harmonized soft tones, can only be done by working from a model or a photo. The schematic study of volumes done before helps in understanding the positioning of the parts.

Light and Shadows on the Figure

Shading the figure requires that you work from either a live model or a photo. The schematic of cylinders has so far helped us to understand the distribution of different volumes, but the actual subject needs more subtlety and more soft, detailed transitions. The range of colors used for drawing has sienna as the base (sanguine could be used just as well). The sienna is darkened in places by sepia. You can get this range with colored pencils as well as chalks.

Above are shown the shades that were used to establish values and model the figure. This array, although enhanced with colored pencils, looks like sanguine chalk, a medium that is perfect for shading the figure, especially a nude figure.

FROM MONOCHROME TO COLOR

The difference between monochromatic and color shading is like the difference between working with a graphite pencil and working with colored pencils. In these two photographs, you can see how the order of values and the shading system are the same in both cases. It is a good exercise to make drawings with graphite pencil shading (lightly shaded) and then color them according to the shading you sketched, adapting the colors to the values you used for the graphite pencil drawing: light colors for the light shading and darker colors for the dark shadows.

Masters of Colored Drawing

Drawing in color with mediums such as sanguine, chalk, or colored pencils has attracted almost all of the masters of drawing and painting. This is not surprising, because the interplay of color among the paper's color, the white highlights, and the light tonalities of the drawing can lead to fine results. It is worth studying the works of great artists to see how they resolved the questions of value, modeling, light and shadow, etc. In the majority of the cases, and in all of the examples here, these works are masterpieces of synthesis of lines and smudges, volume and color. The volumes are perfectly defined and explained, sometimes by only a few lines or a little shading. Works like these are the best possible lessons in shading.

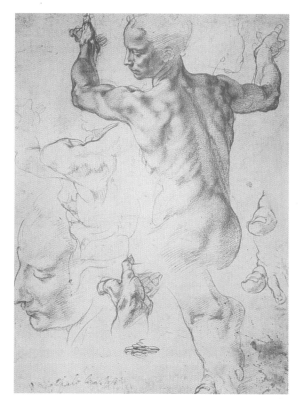

Michelangelo, Study of the masculine figure. *Metropolitan Museum of Art, New York. Michelangelo used only sanguine chalk, working on a cream-colored paper that highlighted the reddish middle values. The strength of the volume was created with very fine lines and light shading.*

Antoine Watteau, Two studies of the feminine figure. *Private collection. This is a good example of this artist's typical drawing technique: drawing "with three colors" of chalk — white, black, and sanguine. This method has become a classic and is still very much in use today.*

François Boucher, Study of a masculine figure. *Private collection. A perfect example of how to combine charcoal or black chalk with white chalk. The paper's grayish color is the perfect support for the play of the different values of light and shadow.*

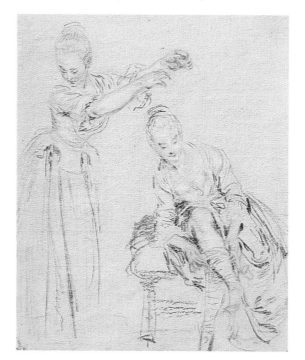

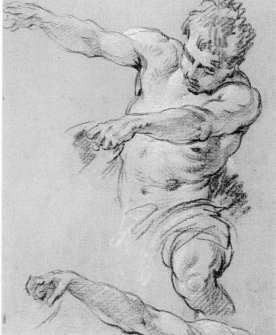

Perspective and shading in landscapes

As we go through the exercises in this chapter step by step, we will see how to shade using colored pencils and chalks. We will also see why it's necessary to consider perspective in order to avoid serious errors in some compositions.

Perspective problems in landscapes usually tend to be not very complicated and can be solved by applying some of the basic ideas of perspective that we have already studied. In general, these problems are usually related to drawing buildings — namely, forms that have straight lines and regular planes. We will look at some of these questions in the following drawing exercises. We will see that they are very easy to solve and that once they are taken care of at the start of the drawing, we will not have to pay much attention to them. What is truly important is the drawing; perspective never should be used as an artistic end in itself, but rather as a means to solve drawing problems which otherwise would give the drawing a strange or distorted look. Once the form is defined with correct perspective, you can move on to what is important, which in these exercises is creating light and shadows, the modeled shape, and the values of the form. In the first exercise, we will observe the creation of value and form using colored pencils. In the second exercise, we will see how to get highly expressive effects by simple means. A simple drawing of a house will be the basis of both examples.

What is important in these exercises, besides the form in perspective, is the resolution of light and shadow, modeling, and values of the form

These two images are the end results of the exercise on the following pages. Both drawings started with simple perspective problems that were easy to solve through building up and shading of the forms.

A Landscape with Colored Pencils

This landscape calls for pencils of a cool color array: blues, grays, and greens. That is the tonality of a Nordic countryside like the one in the photo. There is reduced light, which means that we want to concentrate more on the color shading than on contrast. Since there are no bright lights or dark shadows, there is contrast between the black wooden façade and the white window frames, but it is more a contrast of color than of light. This is a perfect landscape for working with colored pencils, because they are more adequate for creating subtle intonations than strong pure colors. The initial drawing always is important, and in this case is a rough sketch of an almost perfect cube on which a triangular form of the top of the façade was added.

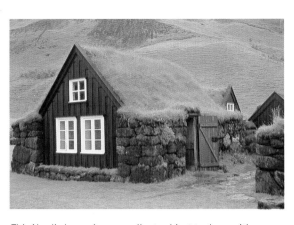

This Nordic house is an excellent subject to draw with colored pencils, because it has few contrasts and many chances to blend, within a color array of cold tones.

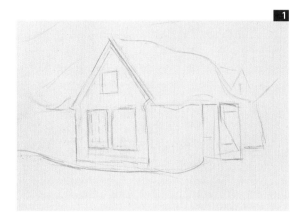

MATERIALS
- A range of colored pencils in light and dark blues, various greens, yellow, sienna, gray, and black
- Smooth-grained drawing paper

1 There are minimal perspective problems here. The horizontal lines of the house gradually recede to the right. To solve this, you don't have to find a vanishing point; you simply have to make the edges of the roof slope to the right. The rest of the drawing is very easy.

2 To make the dark tone of the façade, we use pencil strokes of either two dark blues or of a dark gray and a blue. It is better to progressively darken an area than to injure the paper by pressing the pencil's point directly into it.

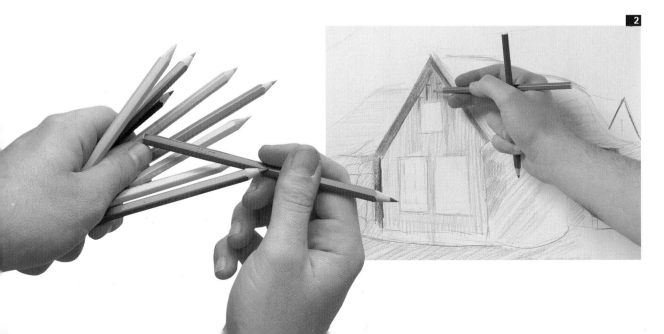

FROM LESS TO MORE

As a general rule, building up color is done by starting with an overall light tone which we little by little intensify. This is especially important when drawing with colored pencils. By progressively building up the color, we avoid mistakes that are hard to correct, and we are able to see at all times how the dark and light values are relating to each other.

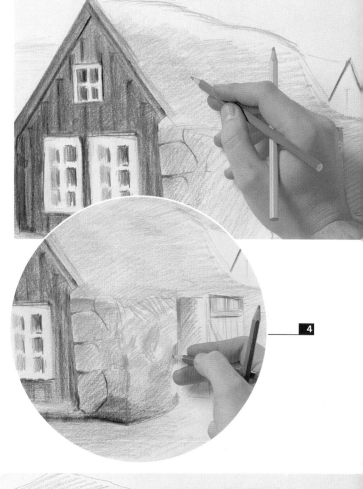

3 When the house's façade is dark enough, we can work on the grass-covered roof. We get the color by making any lines of different greens and by adding yellow for the lightest areas. The pencil strokes should follow the direction of the thatching if possible.

4 We use sienna and gray to get the color of the stones. In the darkest areas, we add touches of blue. Once the color is obtained, pass over the joints between the stones with a dark gray.

THE INTENSITY OF THE LINES

To get the best results from colored pencils, overlay lines of different colors and intensity; there are few occasions when you want to have a solidly colored area.

5 Use a greenish gray to darken the hills in the background so that the roof stands out. This way the effect is soft and shaded, but of enough contrast that all of the forms stand out.

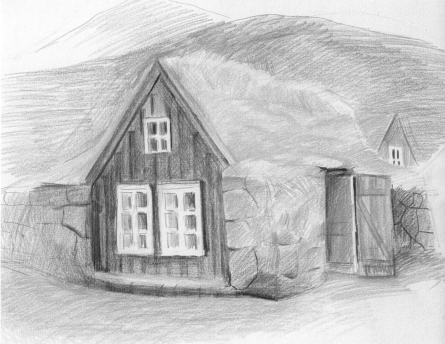

SKILLS
◆ Layout ◆
◆ Perspective drawing ◆
◆ Values with colored pencils ◆

Representing Light

We already know that light is expressed through shading, but this next subject appears to have only white, intense Southern European sunlight and no shadows — a big difference from the soft and gray lighting in the Nordic house. The stark contrast between the whitewashed walls and the pure blue sky is striking. The subject, which at first sight appears difficult to capture through drawing, must be studied thoroughly before beginning. In order to emphasize the contrast between the blue sky and the bright white, we need a deep ultramarine blue. Aside from these considerations, there is also a small perspective problem which may be resolved in the first drawing phase by paying a little attention to the basic lines of the composition.

◆

The intensity of the light can be shown by using dark blue paper, which will enable the white light to stand out strongly

◆

MATERIALS
- Charcoal stick
- Charcoal pencil
- Stick of white chalk and white chalk pencil
- Sanguine chalk
- Deep blue Canson charcoal paper

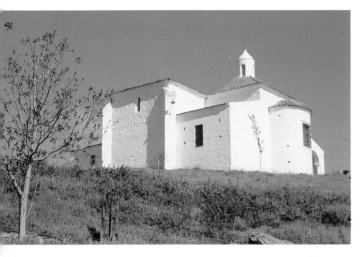

The photograph shows the exceptional brightness of this subject (a monastery). There are hardly any shadows, which are replaced by the intense whiteness of the walls.

Rough sketch in perspective.

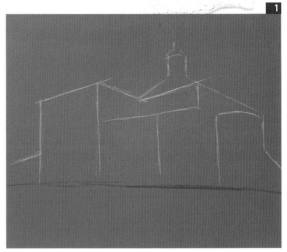

1 This first drawing is very simple, but try to draw it with the correct perspective. The simple two-point perspective (two vanishing points) can be sketched by eye. The rough sketch to thelower left diagrams the basic concept that determines this perspective, in case you have any doubts.

SKILLS
◆ Drawing in perspective ◆
◆ Layout ◆
◆ Blending ◆

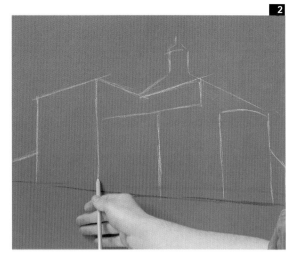

2 A ruler is not necessary in order to make the straight lines in the drawing: simply hold the chalk pencil straight against the paper and draw carefully. Do not make heavy marks, in case it is necessary to erase any lines.

3 When placed on its flat side on the paper, the white stick of chalk lets you rapidly color the walls. This tone has different levels of white, which you get by varying the pressure on the chalk.

THE DRAWING'S PERSPECTIVE

The drawing of the house was done with two-point perspective; the house was viewed from one of its corners. The depth lines of the façade's sides are extended towards vanishing points on the horizon. However, in this drawing, the vanishing points and horizon are not seen, but are implied. The perspective drawing is constructed as if the building were situated on a flat plane. The horizon is at the height of the horizontal dashed red line (see p. 66), and the converging depth lines (also in red) extend to the right and left.

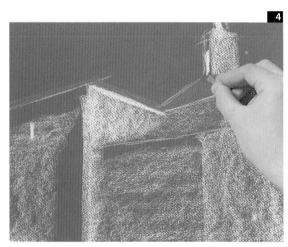

4 The walls are covered with a light application of chalk. Where there are shadow areas, we left the paper uncovered. With sanguine, we lightly colored the roof without drawing any details; we save them for the end.

5 By blending the chalk with our fingers, we create a unified tone and give the painted walls a solid appearance. The brighter parts of the wall stand out with their intense white and contrast with the walls that have been done with much softer strokes.

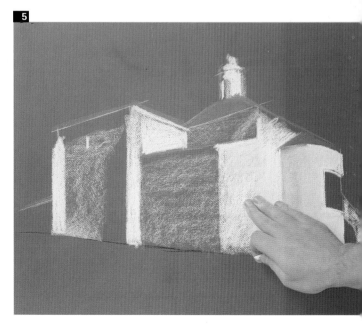

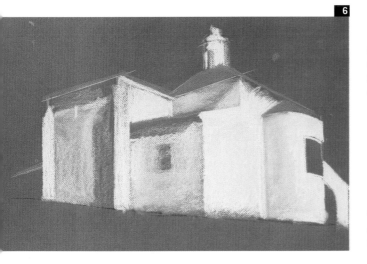

6 With only a couple of steps, we have made a great deal of progress in the drawing. Everything is based on the contrast between the white marks of different intensity, which cover the paper more or less. The blue in the background acts as the shadow, and the more covered it is with white chalk, the brighter the surface.

7 Once all of the color areas are blocked in, we now begin to draw the details, such as the eaves of the roof and the small windows. A charcoal pencil is very useful for drawing details because the black stands out against the blue and its point is finer and harder than a charcoal stick.

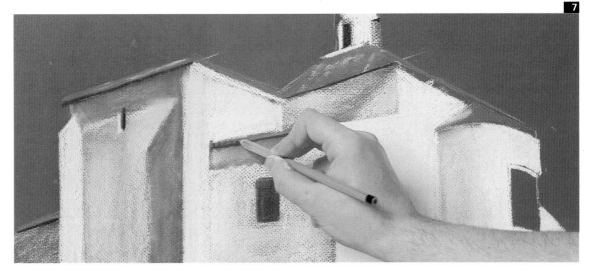

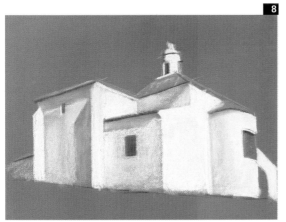

8 Arriving at this point has been very easy. In this subject, the light and shadows are perfectly defined, with hardly any transitions from light to dark, and there are few details. The main work lies in making sure that the white areas are done with the correct values.

WORKING IN THE NEGATIVE

The shading in this drawing is unusual. Normally, you would darken the shadows and leave the light areas untouched. But when you draw on a dark-colored paper, you have to work the other way around, progressively lightening the light areas with light-colored chalk or pastel. Drawing this way is neither harder nor easier than the conventional way; you simply reverse the procedures. In this drawing, the clarity of contrast between light and dark has made the work easier. In drawings on white paper, the light shadows let some of the tone of the paper show through; in this case, the shadows are the parts that aren't covered completely and so look darker.

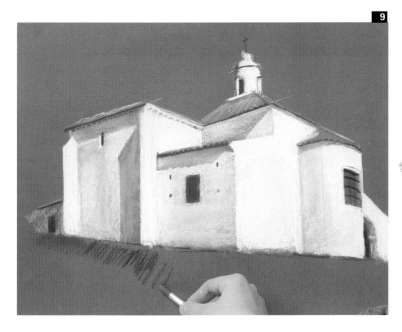

9 The drawing's foreground can be done with color, but to keep the powerful effect of light, we are going to use charcoal lines, which should be soft and slanted so that they look like grass and underbrush.

SHADOWS AND THE PAPER'S COLOR

When we work with dark papers, we are using their color as our shadows. In this drawing, the shadows of the house are nothing more than light layers of white chalk which let the background color show through.

10 On the edge of the hill, where the building's base starts, we make small lines with the charcoal's point so they stand out against the white of the building. These lines, which represent grass, have to be much smaller in this area than in the other ones so that they appear farther away.

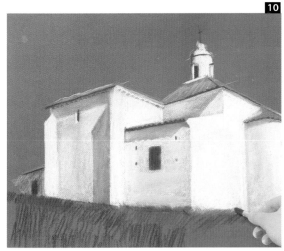

11 White chalk is used on the incline of the foreground, but work with lines rather than wider marks to fit them in. To make fine lines, sharpen the chalk with a cutter blade, making sure you do not break it. The lines should be curved and should slant to the right and left so that you have the effect of high grass and shrubs.

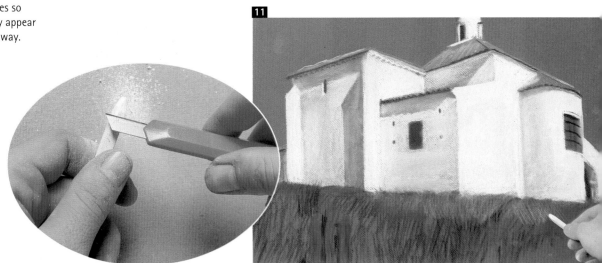

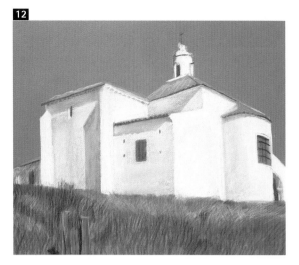

THE FINAL FIXING

Charcoal, as well as other drawing mediums that can smudge very easily, since they are not stuck together and their particles are distributed over the paper, has to be sprayed with a fixative as soon as the work is finished. For chalk drawings, it is not necessary to take many precautions, but make sure to hold the drawing vertically while it is dampened with spray and evenly apply light coats of fixative without overspraying any one spot.

12 The foreground is completely finished. The most important concept for this area is that the length of lines diminishes as they get further away. To emphasize the foreground, we drew a fence. Its size helps to create the sensation of distance with regard to the background.

13 We added some clouds to the final drawing to soften the starkness of the blue background and to give a tone to the sky. We made the clouds very carefully by lightly drawing with white chalk and sanguine and then blending them with the fingers.

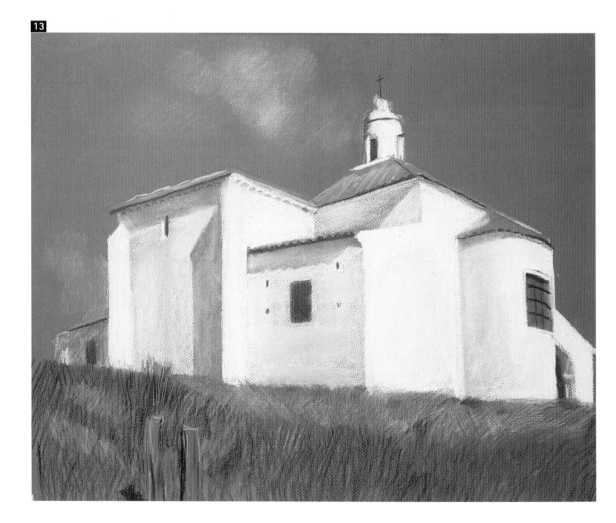

Laying out and shaping the figure

The layout technique we described earlier using simple forms will now be very useful for us. In this section, three figure drawings are developed, using three techniques. At the beginning of each exercise is a basic sketch to help you with the general interpretation, which is then developed through shading and modeling (shaping).

Drawing a figure can be done in many ways. Laying it out with simple geometric shapes is a technique that allows you to have great control over the forms. However, a figure can also be laid out with loose lines, seeking the basic directions of the pose through angles and curves that do not necessarily create geometric shapes. This is the usual way of doing jottings and quick sketches, and is good practice so that your hand becomes adept at freely drawing lines, which makes the forms appear more natural and spontaneous. Nevertheless, everyone develops in his or her own way, and it is better that the geometric figures help you until you can dispense with them — until they become more of a nuisance than a help. The fig-

◆

A figure can be laid out with very loose lines that capture the essential directions of movement of the pose

◆

ures that we will develop in these exercises are not too difficult. They involve blending charcoal, chalks, or sanguine. The number of light and dark values is limited, and there are not that many details to worry about. We will see that quickly interpreting a subject will help you with modeling when you are working with easily blended mediums: you draw a dark spot and extend it with your hand to make the shadow. This allows the shadows to grow with the forms and create the volume. The first example uses more conventional shading, with pencil, and does not emphasize the shadows much, to avoid overwhelming the natural grace of the pose. The layout in this exercise is very simple and can be created with a few well proportioned lines.

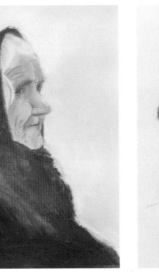

These drawings are the end stages of the exercises that follow: three very different figures were created through shading and simple modeling.

A Pencil Sketch of a Figure

In this exercise, we will see how to draw and shade a figure with a pencil. The subject can be right in front of you: a friend or a family member can pose for you for an hour (of course she can take a break when necessary), which is about how long a session should last. The shading should be light and should not be focused on a specific point, and you should leave large sections unshaded so that you do not overwhelm or complicate the work. The little shading that does exist, however, should be in placed in areas that you want to emphasize to show the figure's depth. The hair is one of these areas, also the arm and folds in the pants. Besides shading the figure, you will also have to describe the folds and wrinkles of the clothing, paying special attention to how the folds fall so that they do not appear too stiff. Also, you must emphasize the direction of the lines in order to define the figure. They define the volume and change direction according to the orientation of the surfaces — flat, curved, frontal, or lateral.

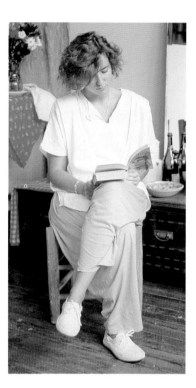

We can easily draw this figure from life by asking a friend or family member to pose for us for one hour. The drawing, done according to the methods shown here, shouldn't take more than an hour.

THE BASIC PLAN

This could be your basic plan. Everything is enclosed in a rectangle. If we succeed in giving this rectangle the correct height and width, we have solved a good part of the problem that this drawing presents. It is also important get the precise angles of the legs and arms, so that the figure appears to be really sitting.

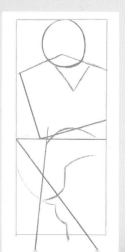

MATERIALS
- HB pencil
- 3B pencil
- Smooth-grained white drawing paper

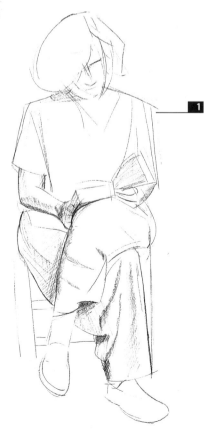

1 The preliminary sketch lines are still visible in this picture (the curve of the hair and the lines laying out the shoulders, arms, feet, etc.). They are finer than the shading lines, and are drawn with a soft pencil without pressing too hard. The directions of the lines follow the form, as we can see in the shadow of the book's pages.

2 The shading is progressive throughout the entire drawing, without any abrupt changes, and we work on the whole drawing. Little by little, we begin to shade the deepest shadows. We are also drawing the facial characteristics with some well-distributed lines without focusing on them or detailing them too much.

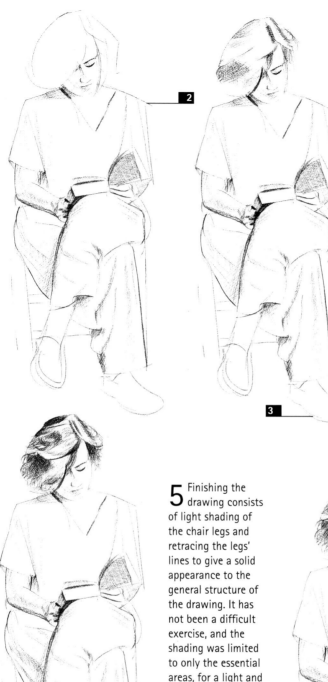

3 Here we have emphasized some important lines (this is also a way to make the form and volume stand out): the inside of the right leg, the lower part of the right arm, and the edge of the hair. This reinforces the general structure of the drawing and adds clarity. We have also begun to shade the hair with some central lines that give form to the wavy hairstyle.

4 You can see how we have to shade the hair. It is necessary to work calmly, studying the model carefully, observing the direction and the curvature of the hair's waves, and using pencil lines to draw the hair ends that appear on the outer edges.

5 Finishing the drawing consists of light shading of the chair legs and retracing the legs' lines to give a solid appearance to the general structure of the drawing. It has not been a difficult exercise, and the shading was limited to only the essential areas, for a light and harmonious result.

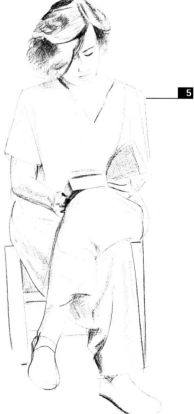

SKILLS

◆ Layout ◆
◆ Pencil shading ◆

A Face in Profile

The mediums used in this exercise are chalk and charcoal. The drawing is based on strong tonal contrast that becomes an extreme exaggeration of value. Instead of gradual differences of value, the contrast between black and white dominates the composition. Blending will not be used to soften the intensity of the shadows, but will used to extend the charcoal to create volume. Only in the face will there be gradual and subtle tonal changes.

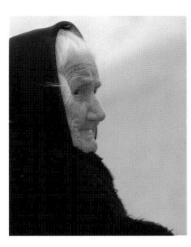

The strong contrasts and the simplicity of the form are the most interesting characteristics of this image. The objective of our drawing is to preserve these characteristics at all times.

MATERIALS

- Charcoal pencil
- Charcoal stick
- Sanguine chalk
- Sepia or sienna chalk pencil
- White chalk
- Cream-colored Ingres charcoal paper (or similar paper)

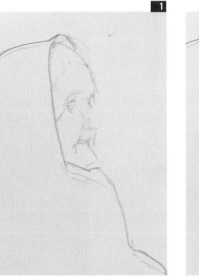

1 The first drawing is very simple as long as we have a clear image of the rough composition in our minds, which is the distribution of the forms on a diagonal line. It is also important to quickly draw the features in order to check their proportions with those of the whole work. For this work we used a charcoal pencil and drew soft lines.

2 To get the face tone, we extend soft sanguine marks, leaving the area where the woman's white hair will be untouched. Make sure you do not cross the drawing's outlines so that the sanguine doesn't become muddied and the outlines don't become blurry. Once you have done this, carefully blend the face area.

SKILLS

◆ Layout ◆
◆ Blending ◆
◆ Shading ◆

A DIAGONAL PLAN

Everything in the figure's layout is based on the fact that it fits at an angle to the rectangle, so the sketch is dominated by one clear diagonal line. Along this diagonal line we will place the oval face and the wrinkles in the clothing. It is an extremely simple sketch which only requires one correct calculation — the angle of the diagonal line.

3 With the chalk pencil, we shade the eye socket, outlining the eyelids. Draw softly because later it will have to be blended, and you do not want any traces of lines.

4 The woman's shawl is a dark black that can easily be represented by charcoal marks. Make them energetically without worrying. We will later blend all the lines together.

3

4

STRENGTH AND DELICACY
These two concepts go hand in hand to enhance our drawings: strength in the contrasts and delicacy in the blends. The strong black color of the shawl enhances the delicate features of the face, and vice versa.

5 Over the soft sanguine blending, we draw the details of the face, the wrinkles and folds, using a chalk pencil. Make sure you pay attention to the different directions of the wrinkles so that you do not create any deformities.

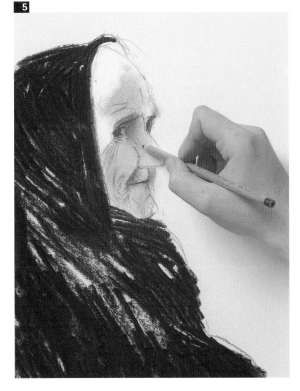

6 We made the woman's white hair with smudges of white chalk, which make a pure contrast with the black of the clothes. We now energetically blend the charcoal lines, moving our hand in the direction of the clothing's folds and creating a curve at the shoulder.

5

6

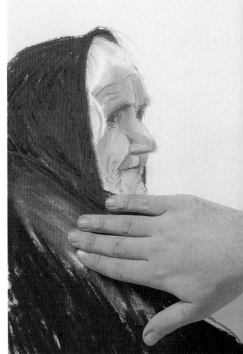

THE VIRTUE OF SIMPLICITY

Subjects should be conveyed by simple means; look for simplicity in the composition as well as in the way to execute it. Although this is not always possible, in most cases it is better to leave something out than to overdraw. We can always retouch something, and we want to do our best work, but every drawing comes to a point where too much detail can ruin the overall effect. When we come to this point, we can consider our drawing finished.

7 Over the white mark of the hair we emphasize some locks of hair so that it does not look like a smudge. Drawing some soft lines with the chalk pencil, we give the impression that the hair is truly pulled back. You can see in the image how we spread some sanguine chalk lines in the background so that it is not completely white.

8 This is the final result. In the background, we mixed the sanguine marks with white chalk to lighten the tone; we leave it as an undefined smudge that gives a little bit of atmosphere to the drawing. The process was rather quick. The fast blending allowed us to make a large part of the drawing in no time, making strong contrasts that give life to the composition.

A Sketch with Sanguine and Toned Chalk

The difference between a finished drawing and a sketch is hard to define. Very often they are confused, and sometimes a sketch may be more interesting than a drawing that has been worked on more. It all depends on the subject and what it demands from us. In general, figures in the landscape lend themselves to sketching to capture quick movement (the figure is not posed as in the studio, natural light changes, etc.). The sketch demands synthesis, using a few lines and marks to capture the essentials of the composition, shading, and modeling. The figure we will use in this step-by-step exercise is very interesting, especially because of his full, attractive clothing, which suggests using a loose and light effect.

BASIC PLAN

This figure's composition is based on a triangular layout, to which the basic curves of the tunic and jacket were added. The rest of the components can easily be added once the overall proportion is finalized. Normally, you sketch without a basic plan, but sometimes it worth the trouble to draw one in order to get a good positioning of all of the parts.

MATERIALS
- Sanguine chalk
- White chalk
- Sepia or sienna chalk
- Charcoal pencil
- Pale rose-colored Canson charcoal paper (or similar paper)

Here is a figure in the open air with an interesting play of light that calls for a light and sketchy treatment.

SKILLS

◆ Layout ◆
◆ Blending ◆
◆ Shading ◆

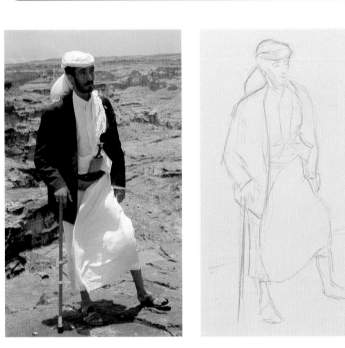

1 We have drawn all of the contours, including the important details, with the sanguine chalk. The sanguine lines harmonize perfectly with the paper's tone since both are in the same reddish family. The simplicity of drawing of the sketch is enhanced if we use colored paper.

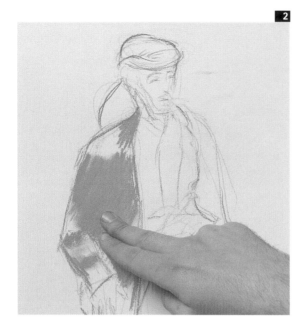

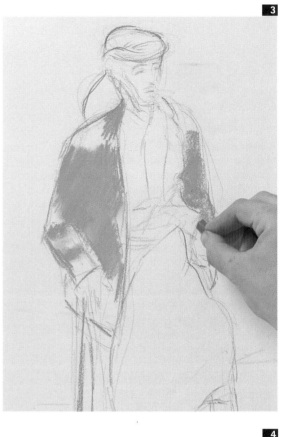

2 After blocking in the area of the jacket with sanguine, we blend the marks to hide the shadows. We left some parts blank, like the shoulder and sleeve, because there the light makes the tones lighter. We made sure that we did not shade past the outlines of the jacket.

3 We repeat the same process on the other sleeve. Here, we had to darken the shadow's tone, outlining it well against the edge of the white shirt. This way the light-colored shirt will stand out more.

4 Here you can see how the sanguine shading surrounds the light-colored parts and creates a sense of relief by letting the figure's central area stand out. By darkening the ground, we create a solid base on which the figure stands.

THE PAPER COLOR

When you draw with colored paper, you must take advantage of the paper's color, using it as an intermediary value between the lightest lights and darkest shadows. The pale paper that we used for this drawing fulfills this function very well, because its tone can express the middle range between the pure white of the tunic and the gray shadows of the clothing's folds.

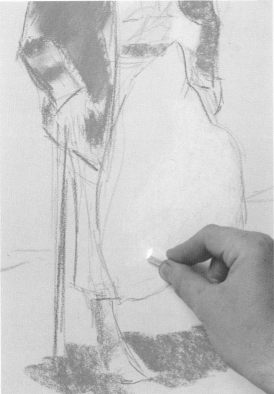

5

HARMONIOUS COLORS

There is a wide range of chalk colors available today, but traditionally only earth-toned colors were available, such as sienna, ochre, and sanguine. These tones are very harmonious and go well with each other, and are suitable for all kinds of modeling and shading. In this exercise, we used two of these colors, sanguine and sienna (plus white), with good results.

5 Now we make light passes with the side of the white chalk, modeling the different volumes of the tunic. The lines should follow the forms of the folds in their lightest parts. The paper's tone will help us make the shadows look luminous; therefore, it is not necessary to darken the shadows too much.

6 We now shade the tunic with the sanguine. Make the blending very light in order to avoid solid, hard-looking shadows, which would not go well with the sheer fabric. The sleeve is the result of blending a few lines of sanguine very well.

6

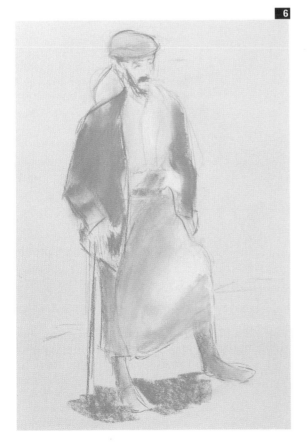

7 The dark lines of the beard, made with a charcoal pencil, not only create the beard but also highlight all of the sanguine shading, introducing a dark aspect that makes the overall drawing appear expressive. These details should be sketchy and general.

7

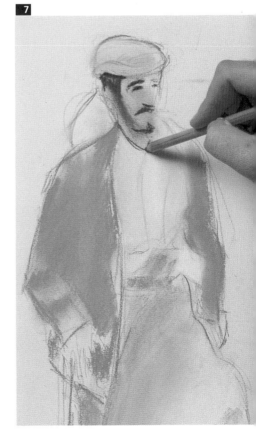

8 To increase the contrast between the light and dark parts and also to give greater importance to the jacket's shading, we went over the sanguine shading with sienna chalk and then blended them in. We made sure, however, to stay away from the light areas.

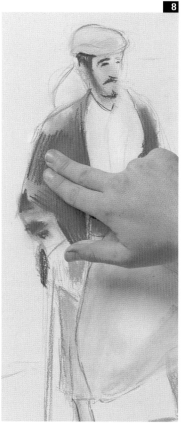

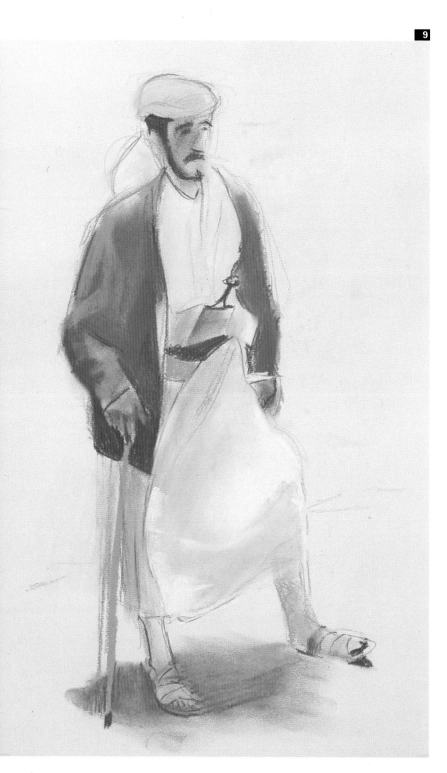

DRAWING RAPIDLY
As you gain practice in drawing, you will notice that the results you get by drawing rapidly will possess their own special look and value, which can easily be lost if you add or touch up too much. Sometimes the best solution is knowing when to stop drawing.

9 The black lines on the face, belt, and sandals have rounded out and have given vitality to the entire drawing. We have been able to see, step by step, how to make a rough sketch: a fast process that is based, above everything else, on capturing the effects of shadow and contrast, using well-placed marks.

Lines and spots: drawing animals

Subjects like this one let you capture the feeling of form, volume, and tone that are typical of drawing with chalk. The following pages show the versatility of this medium, which lets us correct mistakes as well as accent and shade until we get the results we want.

Drawing animals is very attractive to almost everyone who draws, but not many opportunities arise to practice. In this exercise, we will create an attractive scene of wild animals in their natural habitat, exotic and full of color. The subject does not have a defined center or a clearly centered form, which would require a clearly defined composition. The groups of animals are spread across the photo, suggesting a casual and spontaneous layout. One of the most interesting aspects of drawing animals is how a moment in real life is captured, in all its spontaneity. The animals are not posing for us, nor will they let themselves be sketched whenever we want; they are simply there, living, and it is up to us to know how to choose the best moment to draw them. In this case, the moment was already

◆

In this exercise, we create a scene with animals in the wild, full of exoticism and color, of great visual appeal

◆

taken by a photographer, and the drawing starts off from this graphic image (a perfectly valid option from an artistic point of view).

Technically, this process is characterized by the elaborate alternation between lines and spots, between contours and shading, and between the form's precision and the suggestion of volume. The contrast in all of these factors is one of the principal resources that people who draw possess for creating space, the feeling of distance, and atmosphere. The atmosphere in this exercise is warm and dense, which is gained from diffuse marks with warm tones of different intensities, tones made with chalk and shaded with charcoal. This drawing is a complete exercise in which the artist's fundamental resources come into play.

This is the final result of the drawing that will be demonstrated on the following pages. It is an elaborate piece of work, using a combination of all the basic techniques of drawing.

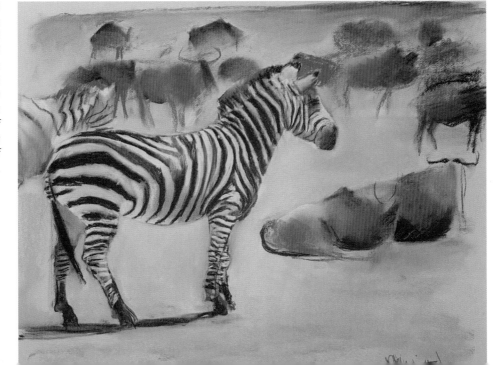

Correcting Mistakes

We must learn from our mistakes, as well as from those of others. Some problems are introduced in this exercise that are later corrected by using the initial mistake. Do not think of them as mistakes, but rather as hasty interpretations that are converted into a useful basis from which to continue. Mistakes happen often. It is good to lose your fear of making mistakes. Thanks to them, we create drawings that we would never have dreamed of in the beginning. A drawing like this, which is based on blending and shading, gives you a wide margin of error; nevertheless, the errors may be removed and covered by working over them.

◆

Mistakes can be converted into useful unexpected suggestions that can lead to new solutions

◆

MATERIALS
- Charcoal stick
- Charcoal pencil
- White chalk
- Ochre chalk
- Sienna chalk
- Cream-colored Canson charcoal paper (or similar paper)

The subject suggests a built-up treatment in which the lights and darks are joined by precise line work.

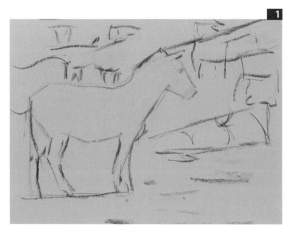

1 In the preliminary drawing, we have made rough outlines of the forms. It is not a true sketch, since there are too many forms and they are too spread out. Each one of the animals is sketched with only its essential lines, and its dimensions are adequately proportioned to the entire composition.

2 We add in some charcoal lines, thinking to blend them in the next stage. The placement of the lines does not have to be precise; we simply drew them where the darkest parts of the composition will be.

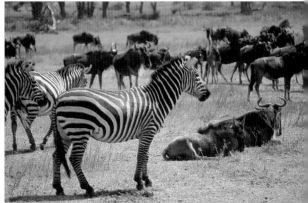

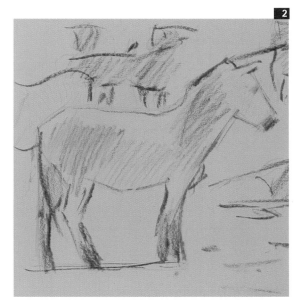

SKILLS

◆ Blending ◆
◆ Shading ◆

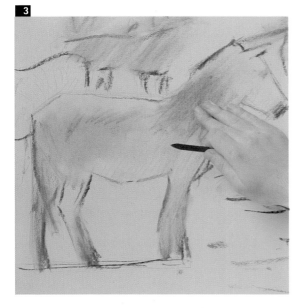

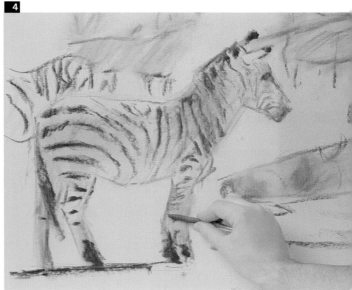

3 We have blended the charcoal lines. To get a general first shading, we blend the marks all over the animal's surface. Because the lines were faint, the shading is light.

4 After establishing the first shading, we drew the zebra's stripes. The lines, as you can see, are not accurate, but are a rough trial to check the width and direction of each one. This kind of trial is best done with something easily erased, like charcoal.

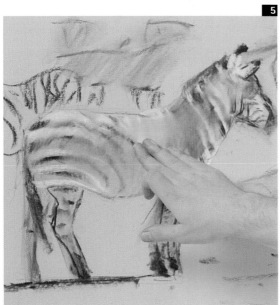

5 Having seen the general effect of the lines, we applied white chalk to the zebra's body and then blended with our fingers. The chalk and the charcoal mix, creating a grayish tone that gives volume to the zebra.

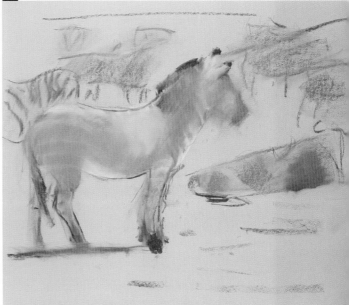

6 In this image you can see the general shading of the zebra; it is rather rough and without precision, but will be a good base on which to draw the stripes. In the rest of the composition, we made some marks with sienna chalk to lightly suggest volume in the other animals.

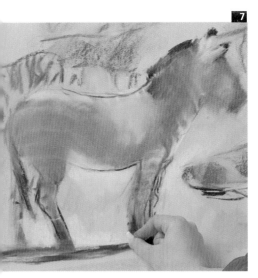

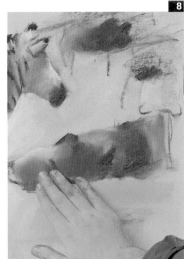

8 Although we have already started making the defining details of the zebra's coat, it's a good time to define the rest of the composition a little more by giving volume to the other animals that stand out. We could do this later, but it is always better to work on the entire composition at the same time.

7 To outline the zebra's body with more precision, we traced over the outer contours with thick lines of white chalk. They will cover the marks that went outside the contour. This is better than erasing, because it does not leave any traces of lines or smudges.

9 We continue modeling the animals in the middle ground a little more so that whole scene gains vitality. Mixing the black charcoal with the sienna chalk will create the dark tones in the animals' bodies. To obtain lighter tones, mix this color with a little bit of ochre chalk.

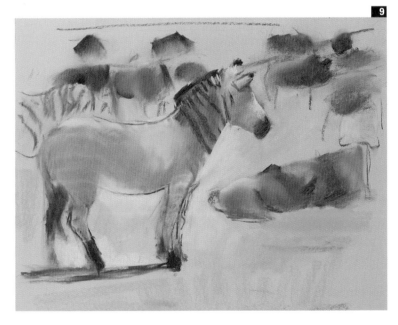

10 Now is the time to clearly define the zebra's coat. The previous lines, which are still lightly visible underneath the shading, will be guidelines to help us. We make the lines with the point of a charcoal stick. We will use a charcoal pencil to darken them later.

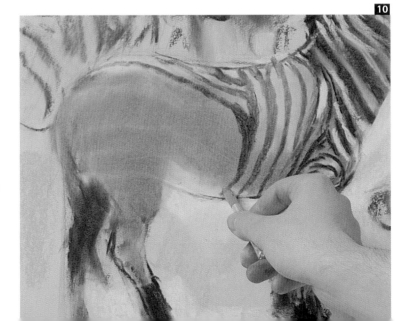

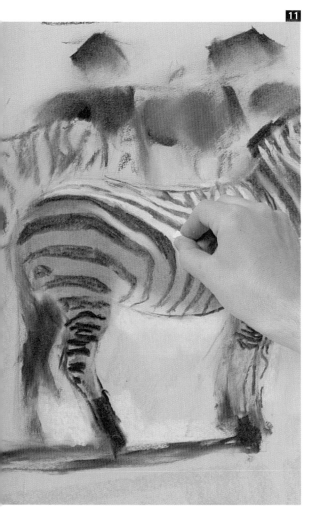

11 The space in between the lines of the zebra's coat will be filled in with white chalk, using the chalk's point. The white spaces should be lighter in the center of the zebra's body and on the hindquarters, where it is in full sunlight.

12 We have gotten a good level of precision in the intricate design of the zebra's stripes, which is one of the most delicate aspects of this drawing. Now, we only need to add volume to the entire form.

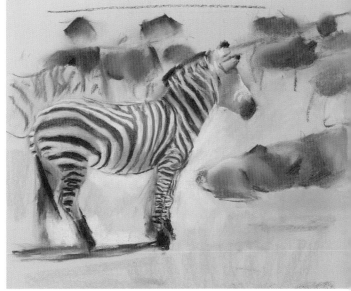

13 By retracing the black stripes with a charcoal pencil and the white stripes with heavy strokes of white chalk, we give volume to the zebra's body and create a convincing representation. Between the feet, we can roughly place ochre chalk marks mixed with white, which will give a basic tone to the background.

BLURRED OUTLINES
It is inevitable that the chalk marks will go out of the lines while you are drawing. In a drawing like this, where you are using several mediums, it is easy to solve this problem by outlining the contours with chalk or conté crayon on the outside before you erase the marks.

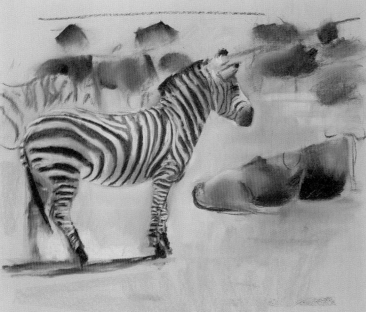

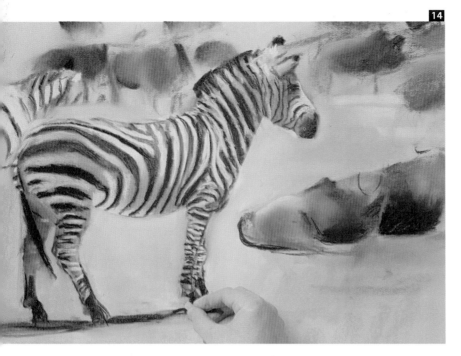

14 To define the secondary contours (the head and the bottom part of the legs), the easiest way was to work around the zebra by drawing outside of the form, and not inside as we would normally do.

15 Here is the final result. We added some details in the background, defining the horns of the other animals, suggesting a hill in the background, strengthening the smudges on the earth in the foreground. The atmosphere is very warm and dusty, like a typical African wildlife scene.

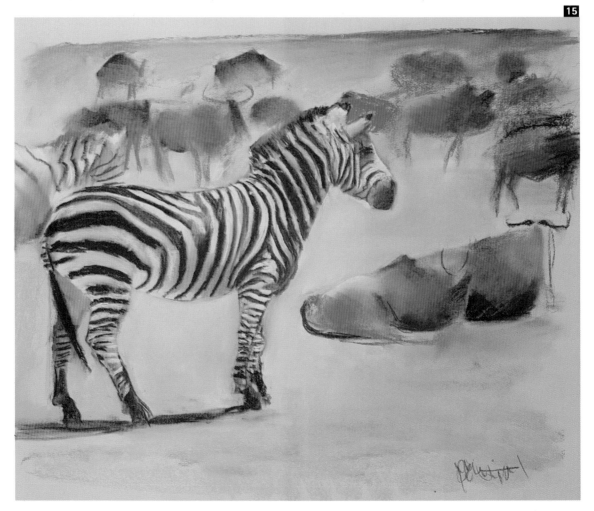

Landscape drawings with direct color

Pastel technique is on the border between drawing and painting. In the following pages, we will pass this frontier and take a glance at the world of color. The technique is based on direct color: touches of unmixed colors, as they come to hand, are applied to the paper. It doesn't require much mixing or modeling to get attractive results.

We are coming close to talking about painting in this chapter, although the following exercises use pastels. Pastels are very similar to artists' chalks — almost the same. The only difference between them is that chalks are harder than pastels and require more work to apply to paper. The method which we are about to see is very simple and does not require much color mixing, something that is an essential part of all painting methods. So perhaps it's not a surprise to find the following exercises in a drawing book.

◆

Direct color means nothing more than pastel marks or lines that are not shaded or blended

◆

Pastels give great results with chromatic, Impressionist subjects like the ones shown here. The drawings may be made by successive applications of colors, similar to the method used by painters of the Impressionist school. This method guarantees vibrant results that do not require detailed composition or an elaborate drawing. Color, with its multiple contrasts, supplies the modeling and shading. The following two examples, given in this chapter, are a perfect ending to this book.

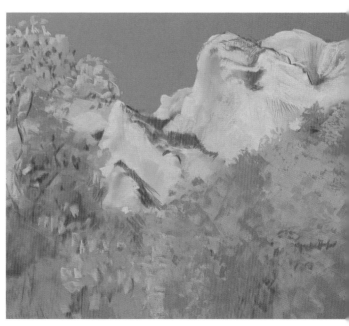

These are the final drawings, which we will recreate in the exercises on the following pages. These two works, which enter the realm of painting, also use all of the characteristic techniques of drawing: marks, lines, modeling, shading, etc.

Autumn Leaves

It would be hard to find a better subject than this branch of autumn leaves for trying out our new technique. In this multicolored image, you can almost count all of the leaves; each one has its own well-defined color. Although it appears very difficult, the subject is quite simple. We will see how to construct it without doing any calculations or making preliminary sketches, simply overlapping different-toned pastel marks, starting with the first color and ending with the last.

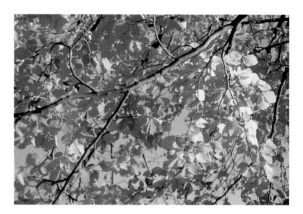

MATERIALS

- A range of pastels: sienna, ochre, red oxide, pale yellow, and bright yellow
- bluish gray Canson charcoal paper (or similar paper)

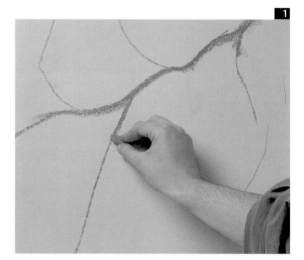

1 To begin the drawing, we simply draw the branch diagonally. We use a thick line in order to position the other marks. There is no preliminary sketch involved — the spontaneity of the lines and marks should be the guide for the entire drawing process.

2 We first distribute the red marks. They should be of similar size, so that it appears that all of the leaves are on the same plane in the composition. Spread the marks in a logical manner along the twigs.

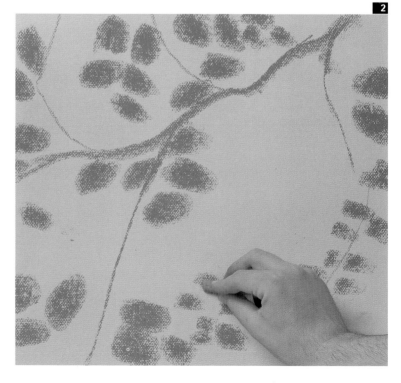

SKILLS

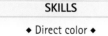

◆ Direct color ◆

THE ORDER OF COLORS

In this example, it is not necessary to follow a precise order in using the pastels; however, it helps to distribute all, or almost all, of the same-colored pastel marks before you go on to another color. You must estimate the amount of space that each group of marks will occupy, and try not to overlap too many colors in one area — otherwise the resulting tone will turn out looking overworked and cloudy.

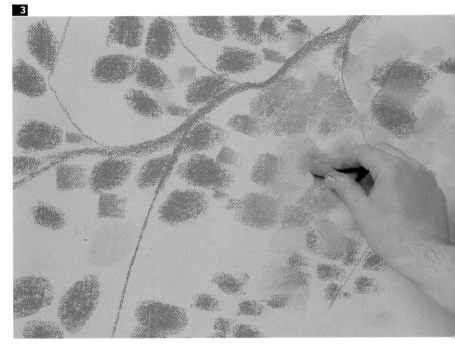

3 We add ochre and yellow marks, the yellow first. They should be placed much closer together than the red leaves. The ochre lets us blend the tones and create new yellowish tones. It's not necessary to blend or mix the colors with our fingers at all.

4 After the applications of color, the accumulated marks give a sensation of thick fall foliage. The warm tones cause the gray background to look like sky.

A Landscape under a Blue Sky

Once again we encounter a luminous subject that is outlined against a perfectly blue sky. The whiteness, in this case, comes from the mountains. We already know how to convey this kind of luminosity: using the paper's color as a contrasting tone. In this respect, the present exercise uses the same concept we used earlier to draw the white monastery. The difference is that here we use direct color. In the earlier exercise, we already saw what the steps are in this technique, so the comments on the following pages may seem familiar.

◆

The color of the paper is always very helpful when you are dealing with strong contrasts

◆

MATERIALS
- Charcoal stick
- Charcoal pencil
- White chalk
- Full color array of pastels
- Blue Canson charcoal paper (or similar paper)

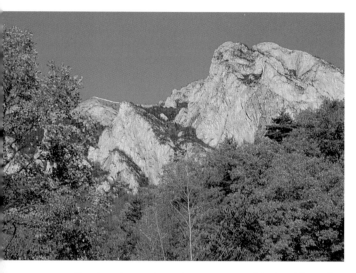

The sky color creates a strong contrast with the white rocks on the mountains, and the mountains serve as the background for the rich colors of the leaves.

1 The preliminary drawing, which does not need a special composition, has to be very simple so that it does not interfere with the later color applications. A group of diagonal lines that can accommodate the curves of the mountains and some light lines for positioning the tree at left are all that is needed.

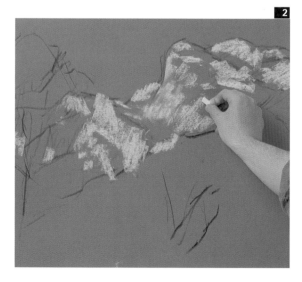

2 With the white chalk stick, we apply marks in the areas where the white of the mountaintops stands out the most. All of these marks will be blended later; therefore, it is not necessary to define their volumes now.

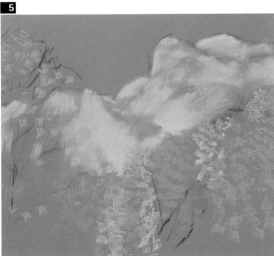

3 As you can see, the blended white chalk marks create the volume of the mountaintops. It is not necessary to exactly reproduce the volume; just try to draw the line of peaks so that it appears convincing.

4 The first marks are only some dots of yellow and orange to express the diverse colors of the foliage. The dots of color should be small because the trees are far from the foreground, so their leaves have to convey the same idea of distance by their size.

5 You can see in this photo how the simple fact that some marks are larger than others suggests that those leaves seem closer. It is important to control the extent of each group of leaves so that it coincides with the shape of the treetops you are trying to create.

6 The overall composition is already well established. Now is the time to concentrate a little bit more on the form and spatial relations of the mountains by applying some charcoal, which will interrupt the white blended areas and create dark areas.

SKILLS

◆ Direct color ◆
◆ Shading ◆
◆ Blending ◆

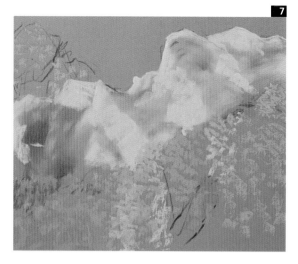

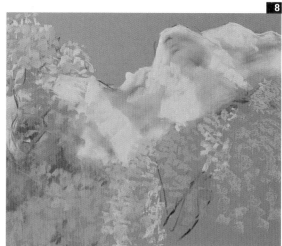

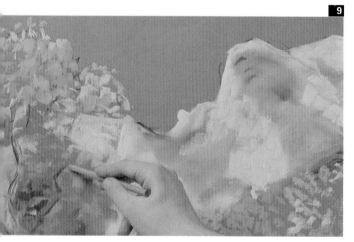

7 Now that the charcoal lines are blended, the mountain forms are shaded, but they still have a blurred appearance. We have to be sure that in the lighter shadows stand out. The blue in the background that the white chalk didn't cover helps to create the tone and enrich the modeling.

8 Returning to the foliage, we once again covered the blank spots with a brown tone between the tree on the left and the mountains. Against this color, we can highlight the warm spots of the foreground.

9 The accumulation of the colors has made the tree's form blurry, mixing it with the background. Using the charcoal pencil, we can restore the tree trunk, drawing over the pastel marks.

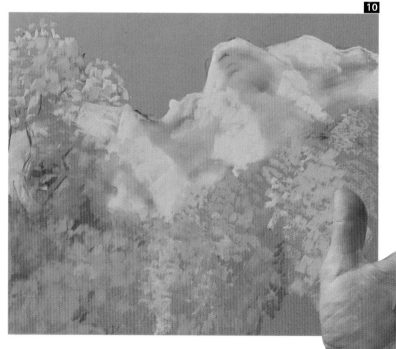

10 The work has a considerable chromatic richness now. From here on, we will continue blending and enriching all of the colors, thickening the foliage, and covering the background with new tones.

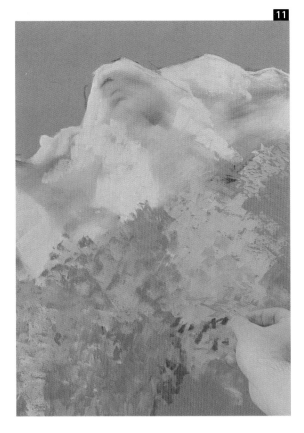

11 The process of adding colors is enriched by overlapping dark tones over light ones that were applied earlier on. By using this method, we make it look like some groups of leaves are in front of others, instead of their appearing to be all in one plane.

12 All that is left is to touch up the mountains and enhance their volume. The mass of foliage has been defined little by little, without blending.

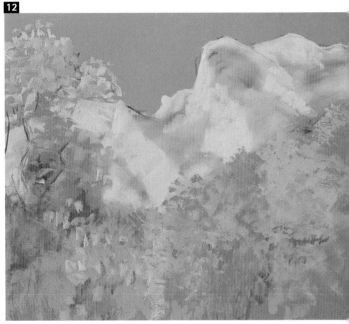

13 The more you define the rocky forms of the mountains, the more clearly the overall composition will appear. There will be a distinct contrast between the edge of the treetops and the mountain chain.

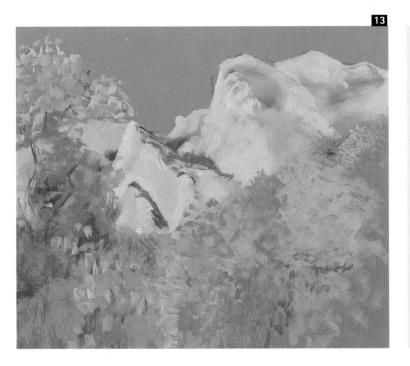

COLOR AND SHADOWS

In this work, the colors don't have shadows. However, light and shade still exist: light colors contrast with dark tones. This relation can be interpreted the same way that shading can. In this case, the values are not shades of gray, but a true color array, and each tone gives its own degree of luminosity to the whole.

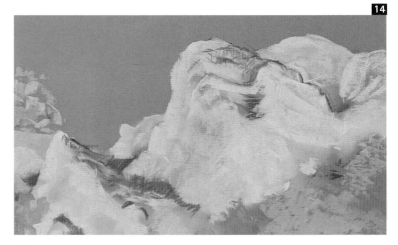

14

CHROMATIC RICHNESS

The time comes when the work gets saturated with color. Then the chromatic array cannot be enriched any more, and any new application of color will only muddy the tones, rather than enrich them. Then it's time to stop, because any further work will detract from the drawing.

14 To define the shadows of the mountains, we use charcoal, white chalk, and some light applications of sienna pastel. This color blends the grays and gives them a light earth tone, which breaks up the excessive coldness of the white and black.

15 Finally, we define the complicated volumes of the mountaintops. Before there were only imprecise blends; now we add more concrete details of the slopes, peaks, low valleys, and the scarce vegetation between the summits.

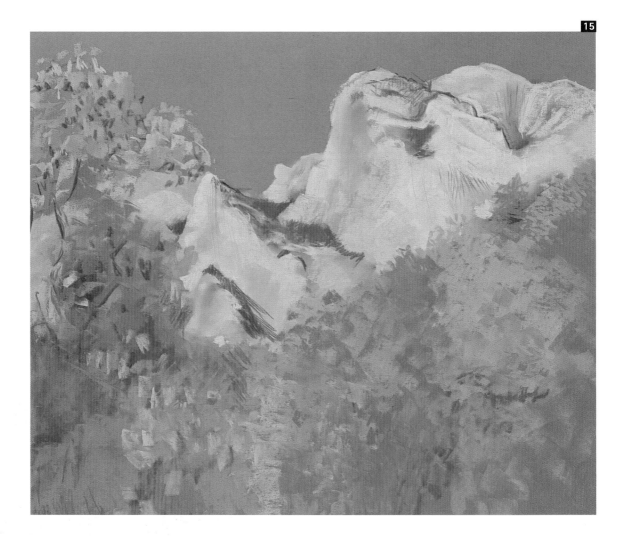

15

Index

Adoration of the Magi, 39
angular perspective, 42
animals, 81–86
Apotheosis of Hercules, 45
arch in perspective, 44
artists' chalks, 24

Bails, Benito, 32
basic forms, 32–38
blending with hands and stump, 24, 53, 57, 67
blue sky, 66–67
blurred lines, 85
boats, 49
Boucher, François, 62
bowl of fruit, 22–23

Canson Mi-Teintes paper, 12
Catalán fresco, 38
chalk: and charcoal (animals), 82–86; earth tones of, 79; man with scimitar, 77–80; Michelangelo sketch, 62; sanguine, 26–27, 62; sharpening, 69; values and shading with, 58–59; for walls, 66–67; zebras, 81–86
chalk pencil, 24, 66
charcoal: blending and shading, 24–25, 56–57, 81–86; cleaning hands, 18; description, 11; erasing and fixing, 14; face in profile, 74–76; in landscape, 69; in seascape, 52; stumps, 24; using hands with, 25
charcoal paper, 12
charcoal pencils, 28, 29
choosing a view, 49
colored paper, 13, 26–27, 74–76, 78
colored pencils, 11, 22–23, 30, 64–65
composition, 45–52
contrast, increasing, 80
cutting paper, 16
cylinders, 54, 60–61

da Vinci, Leonardo, 39
de Vries, Jan Vredeman, 44
della Francesca, Piero, 44
depth lines, 41
direct color, 87–94
drawing board, 16–17
drawing paper, 12–13
drawing rapidly, 80
drawing stand, 16
drawing table, 17
duck, 37

erasers, 10, 14, 18, 30

experimenting with tools, 19
eye level and horizon line, 40–41

face in profile, 74–76
figure: and background, 48; drawing and modeling, 60–61, 71–80
fixing charcoal and pastels, 14, 25, 70, 76
flowers, 43, 51
framing and composition, 47, 48, 49

girls, 48, 61
gouache, 29
graphite pencil drawing, 10, 20–21, 72–73
gray pencils, 23

holders for chalks and leads, 14
horizon line, 40–42

Ingres paper, 12
interpretation of subject, 50–51

keeping work clean, 18
kneaded rubber eraser, 14
kraft paper, 13

lamp, 56
landscapes: autumn leaves, 88; buildings on hill, 28–29; direct color in, 87–94; monastery, 66–70; Nordic house, 64–69; tree and mountains, 90–94
Le Brun, Charles, 45
Lemons, oranges, and roses, 34–35
light and shadows, 53–62, 66–70
lighting for work space, 15
lines, and shading, 54–55, 56

man with scimitar, 77
measurements, 46–47
metal box, 17
Michelangelo, 62
mixed media, 28–29
monastery, 66–70
monochrome to color, 61
mountains, 90–94

Nordic house, 64–65
nude, 26–27, 55, 60–61, 62

optical mixing (colored pencils), 23

palm trees, 42–43
paper: for charcoal and pastel, 12–13, 56; color of, 13, 26, 58; cutting, 16; folded, 30; Ingres and Canson, 12; storage, 17, 30

parallel perspective, 42
pastels, 29, 59, 87–94
pencil sketch of a figure, 72–73
pencils: colored, 11, 22–23, 30, 64–65; graphite, 10; gray, 23; hard and soft, 10, 11, 30, 31, 55; for shading, 54–55; ways of holding, 20–21
perspective, 39–44, 63–68
profile of face, 74
proportions, 33, 46–47

quality of materials, 9

red pepper, 36

sanguine chalk, 26–27, 62
seascape, 52
seated figure, 72–73
shading, 22–23, 53–68, 80
sharpening chalk, 69
simple forms, for drawing, 31–37, 60, 71–80
size of image on paper, 48
sketching, 34–37
sketch paper, 12, 13
spray fixative, 14
stains from erasers, 30
station point, 40
statue, 20–21, 55, 58
still life with fruit, 50–51
storage, 17, 30
Study of masculine figure, 62
stumps, 24, 30
Szafran, Sam, 19

tomato, 36
two-point perspective, 66–67
Two studies of feminine figure, 62

unseen vanishing point, 43

values, 53–62
vanishing points, 41, 42, 43, 66
vases, 59
viewing frame, 47
Villar de Honnecourt, 32
volume, 53, 60–62, 72–73

watering cans, 57
Watteau, Antoine, 62
wet and dry mediums, 28
white chalk, 26, 68–70, 83
work space and habits, 9, 16–18

zebras, 81–86
Zurbarán, Francisco de, 34–35